Cézanne

1839-1906

Page 4: Portrait of the Artist, 1873-1876. Oil on canvas, 53 × 64 cm, Musée d'Orsay, Paris.

Designed by:
Baseline Co Ltd
19-25 Nguyen Hue
Bitexco Building, Floor 11
District 1, Ho Chi Minh City
Vietnam

ISBN 1-84013-771-1

© 2005, Sirrocco, London, UK (English version) © 2005, Confidential Concepts, worldwide, USA

Published in 2005 by Grange Books an imprint of Grange Books Plc The Grange Kingsnorth Industrial Estate Hoo, nr Rochester, Kent ME3 9ND www.grangebooks.co.uk

All rights reserved

No part of this publication may be reproduced or adapted without the permission of the copyright holder, throughout the world. Unless otherwise specified, copyrights on the works reproduced lies with the respective photographers. Despite intensive research, it has not always been possible to establish copyright ownership. Where this is the case we would appreciate notification

Printed in China

"When I judge art, I take my painting and put it next to a God made object like a tree or flower. If it clashes, it is not art."

Paul Cézanne

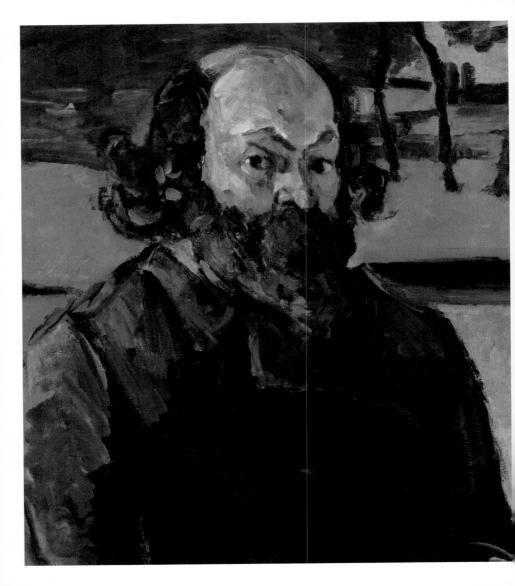

Chronology

- Paul Cézanne is born on January 19, in Aix-en-Provence.

 Studies as a half-boarder at the St. Joseph school together with Philippe Solari, the future sculptor, and Henri Gasquet.

 Studies at the Collège Bourbon in Aix, with Émile Zola and Baptistin Baille. Enrolls at the municipal school of drawing at the Aix Museum.

 Studies law at Aix University and continues to attend the municipal school of drawing from November 1859 until August 1860. Sets up a studio at the Jas de Bouffan.

 Leaves Aix for Paris. Works at the Académie Suisse, meets Armand Guillaumin and Camille Pissarro, and paints a portrait of Zola, destroying it unfinished. Returns to Aix in September and starts work in his father's bank. Attends the municipal school of drawing in Aix.
- Leaves the bank in January and devotes himself entirely to painting. In November he goes a second time to Paris and settles there.
 Works at the Académie Suisse together with Antoine Guillemet, Guillaumin, and Francisco Oller.
- He and Zola visit the Salon and the Salon des Refusés.

 Sends one of his works to the Salon but the Jury rejects it. Copies a painting by Eugène
- Sends one of his works to the Salon, but the Jury rejects it. Copies a painting by Eugène Delacroix at the Louvre.
- The Jury of the Salon rejects his portrait of Valabrègue (V. 126). Cézanne writes a letter of protest to Count Nieuwerkerke, chairman of the Beaux-Arts, with the demand that the Salon des Refusés be reopened. Zola's articles published in the newspaper L'Événement in defence of avant-garde artists are issued in a separate pamphlet with a dedication to Cézanne.
- His paintings *Punch and Rum* and *Intoxication* are rejected by the Salon. Zola defends him in the press (*Figaro*, April 12, 1867).
- Meets Hortense Fiquet (b. 1850), who works at a bookbinder's and also as a model. Once again rejected by the Salon.
- After the declaration of the Franco-Prussian war, he works in Aix and later goes to L'Estaque, accompanied by Hortense Fiquet. Zola comes to stay with him for a short time. After the pronouncement of the Third Republic, his father is elected a member of the Municipal Council and Cézanne a member of the fine arts commission of the Aix school. However, he does not participate in the commission's activities.
- 1872 Birth of Paul, his son, by Hortense Fiquet. Cézanne moves with his family to Pontoise where he works with Pissarro.
- 1873 Lives in Auvers-sur-Oise, working in the house of Dr. Gachet. Pissarro introduces him to Julien Tanguy, the art dealer.
- Takes part in the first Impressionist exhibition (Société anonyme des artistes peintres, sculpteurs et graveurs), held from April 15 to May.15. He exhibits *The House of the Hanged Man* (V. 133), A Modern Olympia (V. 225), and the study Landscape at Auvers.
- He refuses to send his works to the second Impressionist exhibition and in August returns to Paris.

 Works with Pissarro in Pontoise and Auvers, and also in Chantilly, Fontainebleau, and Issy.

P. CEZANNE

1880 In August he stays with Zola in Medan, meeting Joris Karl Huysmans. Lives in Pontoise (but keeps his apartment in Paris) where he works with Pissarro and meets 1881 Paul Gauquin. 1882 Admitted to the Salon as a "pupil of Guillemet." 1883 At the end of December he visits Claude Monet and Renoir. On May 4, he goes to the funeral of Édouard Manet. 1884 The portrait he submits for the Salon is rejected by the panel, and from then onwards Cézanne apparently sends no more of his works to the Salon. Paul Signac buys one of his landscapes from Tanauy. In March, Zola's L'Œuvre is published. Breaks with Zola. On April 28, Cézanne marries 1886 Hortense Figuet. In the summer he lives in Paris and in Hattenville. On October 23, his father dies, leaving him a legacy. 1887 Exhibits in Brussels with "Les XX." In January Renoir stays with him in Aix and they work together. 1888 1889 Exhibits The House of the Hanged Man at Auvers at the World Exposition of 1889–1890. In January he exhibits three paintings at the seventh exhibition of "Les XX" in Brussels, among 1890 them is The House of the Hanged Man at Auvers. In the fall he visits Monet at Giverny where he meets Joseph Clemenceau, Auguste Rodin, 1894 Octave Mirbeau, Gustave Geffroy, and Mary Cassat. Cézanne's first personal exhibition is organized by Vollard on Rue Laffitte (150 works). Two of 1895 Cézanne's landscapes are bequeathed by Gustave Caillebotte to the Musée de Luxembourg. 1897 October 25, death of Cézanne's mother. One of his landscapes is acquired by the National Gallery in Berlin as a gift from a Berlin patron of the arts. 1900 His Vase of Fruit, Glass, and Apples (V. 341), Pool at the Jas de Bouffan (V. 167), and a landscape are displayed at the exhibition "A Century of French Art," held at the World Exposition in Paris 1901 Denis exhibits Hommage à Cézanne at the Salon of the Société des Artistes Français. Cézanne sends several paintings to the Exposition de la Libre Esthétique in Brussels and to the Salon des Indépendants. He builds a studio on Chemin des Lauves, not far from Aix. 1902 Death of Zola on September 29. 1903 Lives in Aix. His paintings are shown at the Impressionist exhibition of the Vienna Secession, among them Mardi Gras and Road at Pontoise. 1904 A large retrospective exhibition at the Salon d'Automne. A large individual exhibition at the Cassirer Gallery, Berlin. 1905 Takes part in an exhibition at the Grafton Gallery in London, organized by Paul Durand-Ruel. 1906 The Château Noir is exhibited at the Société des Amis des Arts in Aix as the work of one of Pissarro's pupils. On October 6, the Salon d'Automne opens, at which ten of Cézanne's works are shown. On October 22, the death of the artist. Posthumous exhibition at the Salon d'Automne 1907

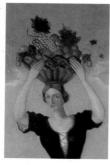

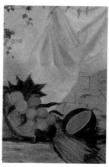

t the turn of the century, Cézanne began to be taken more and more seriously by the avant-garde: Matisse, Picasso, Braque, Vlaminck, Derain, and others, among them young Russian painters whose new art owed much to the master from Provence. However, many of Cézanne's contemporaries did not realize his true greatness.

The Four Seasons

1859-1860 Oil on canvas, 314 x 104 cm each Musée du Petit Palais, Paris

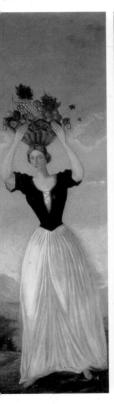

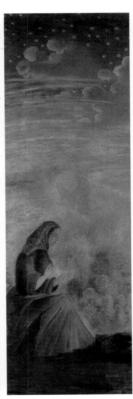

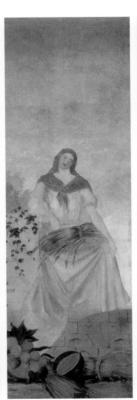

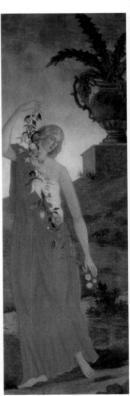

When Paul Cézanne died in October 1906 in Aix-en-Provence, the Paris newspapers reacted by publishing a handful of rather equivocal obituaries. "Imperfect talent," "crude painting," "an artist that never was," "incapable of anything but sketches," owing to "a congenital sight defect" — such were the epithets showered on the great artist during his lifetime and repeated at his graveside.

Two Women and Child in an Interior

1860 Oil on canvas, 91 x 72 cm Pushkin Museum of Fine Arts, Moscow

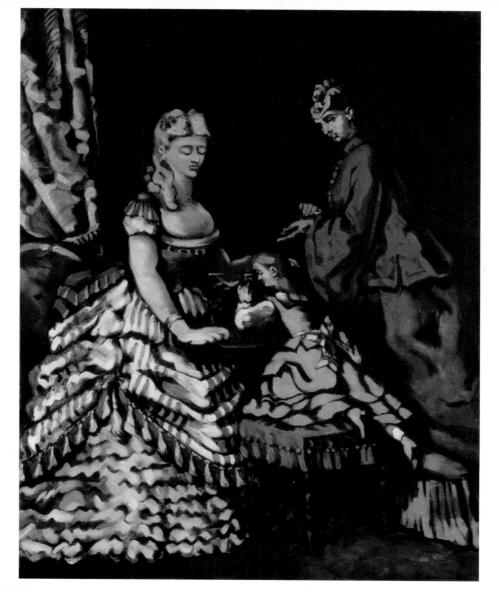

This was not merely due to a lack of understanding on the part of individual artists and critics, but above all to an objective factor—the complexity of his art, his specific artistic system which he developed throughout his career and did not embody in toto in any single one of his works.

Uncle Dominic as a Monk

1865 Oil on canvas, 65.1 x 54.6 cm Metropolitan Museum of Art, New York

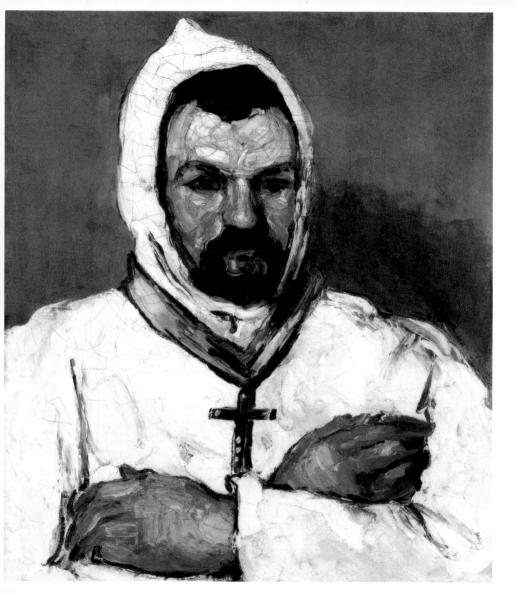

Cézanne was perhaps the most complex artist of the nineteenth century. "One cannot help feeling something akin to awe in the face of Cézanne's greatness," wrote Lionello Venturi. "You seem to be entering an unfamiliar world — rich and austere with peaks so high that they seem inaccessible."

Man in a Cotton Hat

1865 Oil on canvas, 79.7 x 64.1 cm Museum of Modern Art, New York

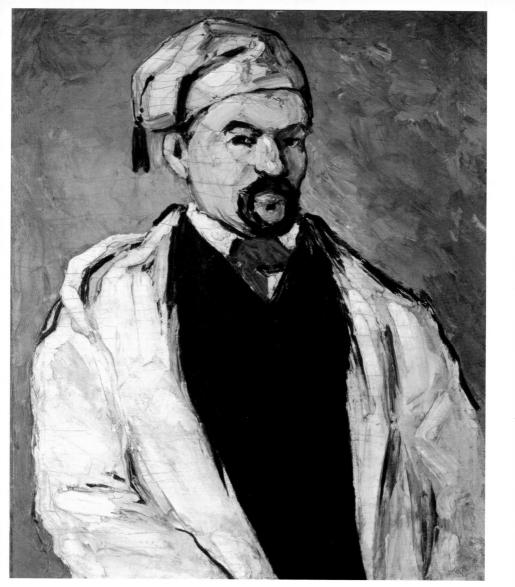

It is not in fact an easy thing to attain those heights. Today Cézanne's art unfolds before us with all the consistency of a logical development, the first stages of which already contain the seeds of the final fruit. But to a person who could see only separate fragments of the whole, much of Cézanne's œuvre must naturally have seemed strange and incomprehensible.

Bread and Eggs

1865 Oil on canvas, 59 x 76 cm Cincinnati Art Museum, Cincinnati

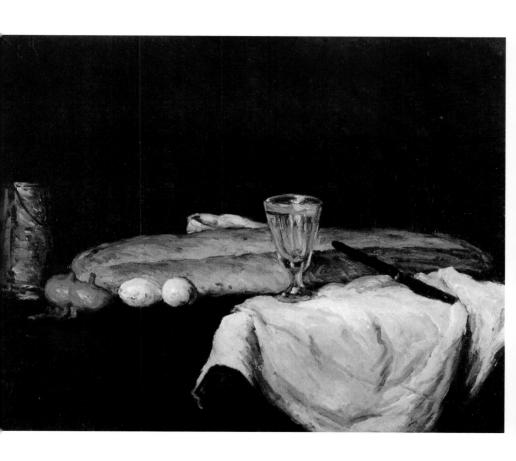

Most people were struck by the odd diversity of styles and the differing stages of completion of his paintings. In some paintings, one saw a fury of emotion, which bursts through in vigorous, tumultuous forms and in brutally powerful volumes apparently sculpted in colored clay; in others, there was rational, carefully conceived composition and an incredible variety of color modulations.

The Strove in the Studio

1865-1868 Oil on canvas, 42 x 30 cm Private Collection, London

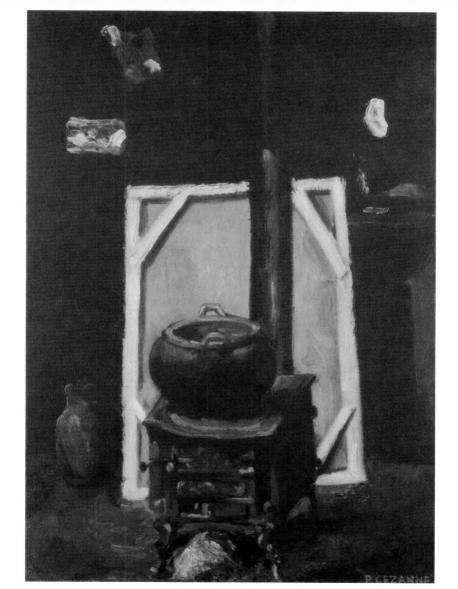

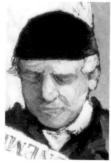

Some works resembled rough sketches in which a few transparent brushstrokes produced a sense of depth, while in others, powerfully modeled figures entered into complex, interdependent spatial relationships — what the Russian artist Alexei Nuremberg has aptly called "the tying together of space."

Portrait of the Artist's Father

1866-1867 Oil on canvas, 119.3 x 198.5 cm National Gallery of Art, Washington DC

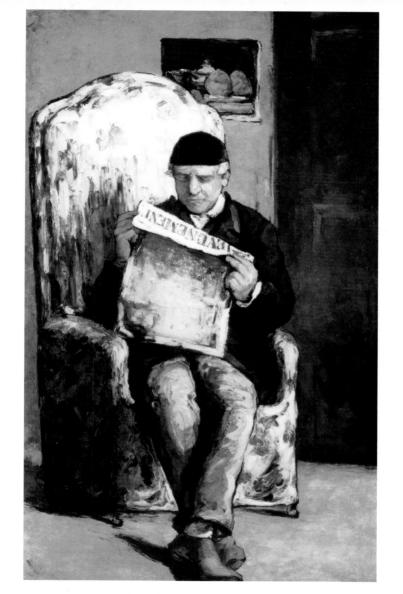

Cézanne himself, with his constant laments about the impossibility of conveying his own sensations, prompted critics to speak of the fragmentary character of his work. He saw each of his paintings as nothing but an incomplete part of the whole.

The Abduction

1867 Oil on canvas, 93.5 x 117 cm The Fitzwilliam Museum, Cambridge

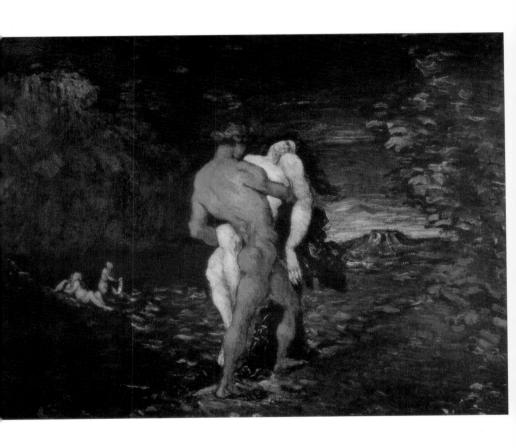

Often, after dozens of interminable sessions, Cézanne would abandon the picture he had started, hoping to return to it later. In each succeeding work he would try to overcome the imperfection of the previous one, to make it more finished than before: "I am long on hair and beard but short on talent."

The Black Scipion

c. 1867 Oil on canvas, 107 x 83 cm Museu de Arte, São Paolo

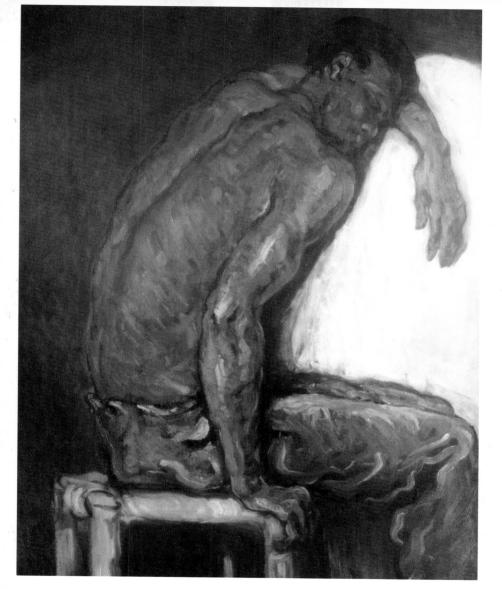

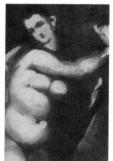

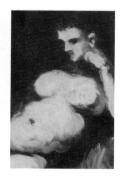

Exactly a month before his death, Cézanne wrote to Émile Bernard: "Shall I attain the aim so ardently desired and so long pursued? I want to, but as long as the goal is not reached, I shall feel a vague malaise until I reach the haven, that is, until I achieve a greater perfection than before, and thus prove the tightness of my theories."

The Temptation of Saint Anthony

1867-1870 Oil on canvas, 57 x 76 cm E.G. Bührle Foundation, Zurich

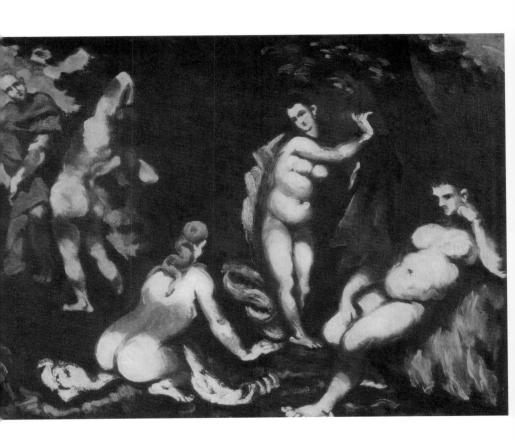

Such thoughts, shot through with bitterness, are a tragic theme recurring in Cézanne's correspondence and conversations with his friends. They are the tragedy of his whole life—a tragedy of constant doubting, dissatisfaction, and lack of confidence in his own ability.

Murder

1867-1870 Oil on canvas, 65.4 x 81.2 cm Walker Art Gallery, Liverpool

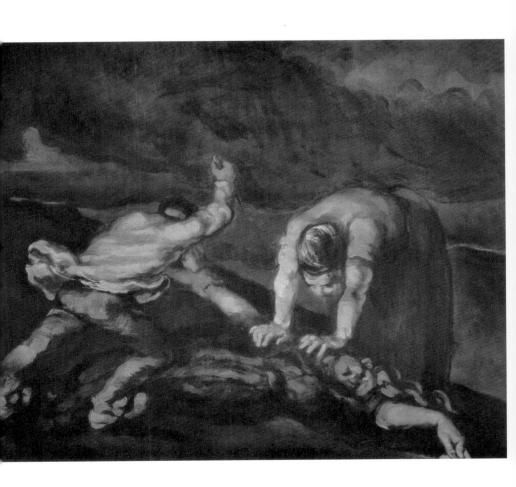

But here, too, was the mainspring of his art, which developed as a tree grows or a rock forms — by the slow accumulation of more and more new layers on a given foundation. Often Cézanne would take a knife and scrape off all he had managed to paint during a day of hard work, or in a fit of exasperation throw it out of the window.

Girl at the Piano (Overture to "Tannhäuser")

1868 Oil on canvas, 57.8 x 92.5 cm Hermitage, St. Petersburg

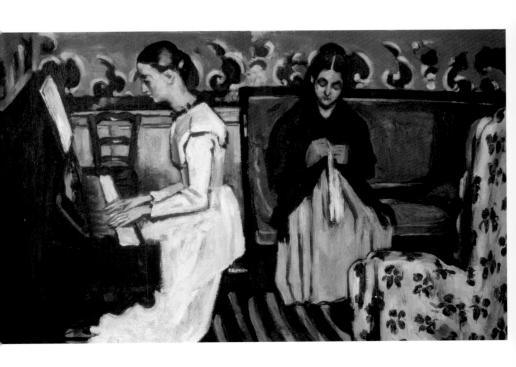

He was also prone, when moving from one studio to another, to forget to take with him dozens of paintings he considered unfinished. He hoped eventually to render his entire vision of the world in one great, complete work of art, as did the geniuses of classical painting, and having "redone Nature according to Poussin," to emulate Poussin.

The Madeleine or Sorrow

1868-1869 Oil on canvas, 165 x 125 cm Musée d'Orsay, Paris

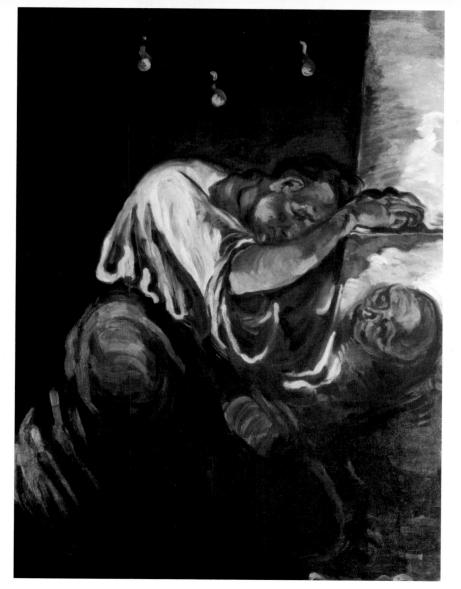

But to a person living at the end of the nineteenth century the surrounding reality seemed far more complex and unstable than to someone living in Poussin's time. Cézanne devoted many years to the search for such means, hoping eventually to bring them all together.

Green Pot and Tin Kettle

c. 1869 Oil on canvas, 64 x 81 cm Musée d'Orsay, Paris

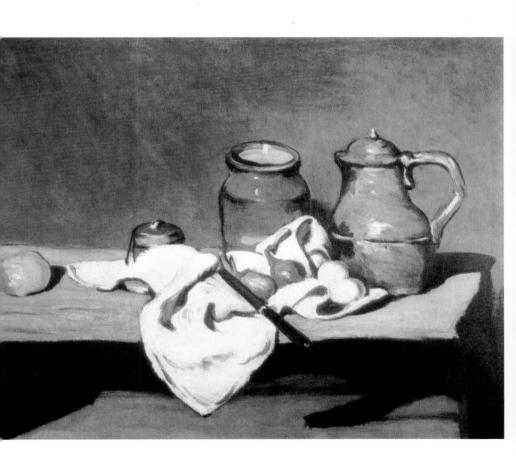

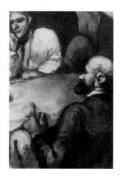

His ultimate aim was to paint a masterpiece, and he did create many works that we now consider to be masterpieces. But apart from that, he evolved a new creative method and a new artistic system which he adhered to consistently throughout his life.

Luncheon on the Grass

1869-1870 Private Collection, Paris

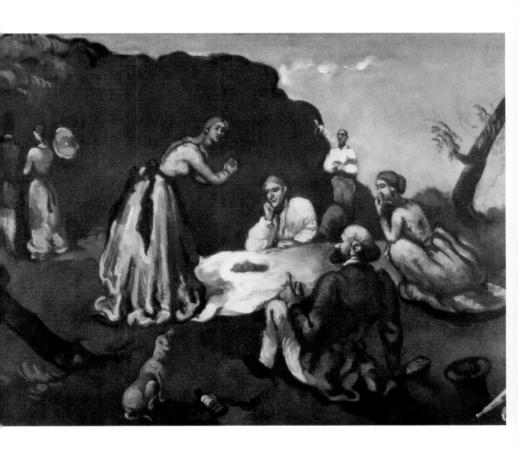

In creating this system he contributed to the birth of twentieth-century art. It would be useless to look for the essence and meaning of Cézanne's new artistic system in his own pronouncements. Cézanne had no use for thoughts on art expressed by any other means except "with brush in hand."

Portrait of Anthony Valabrègue

1869-1871 Oil on canvas, 60.4 x 50.2 cm J.P. Getty Museum, Malibu

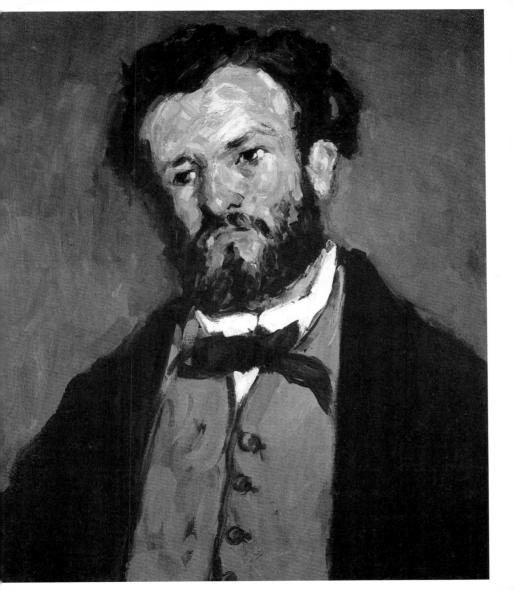

His pronouncements bear the stamp not so much of theoretical postulates as of practical advice to fellow artists. It is not therefore to the artist's theoretical statements but to his works that we must look for an explanation of how his creative method gradually came into its own, how the links of the whole chain which today we justly call "Cézanne's artistic system" were forged.

Pastoral

1870 Oil on canvas, 65 x 81 cm Musée d'Orsay, Paris

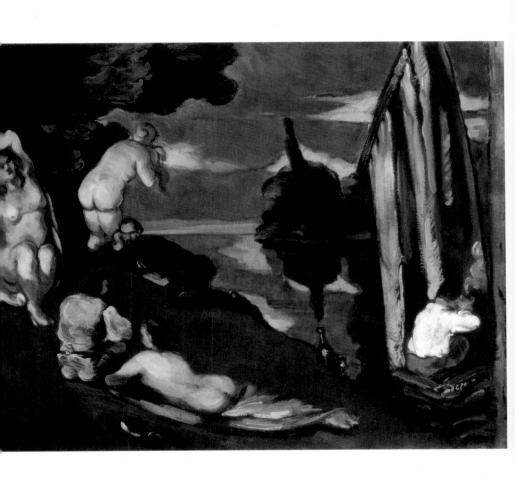

In April 1861, the 22-year-old Paul Cézanne, son of a wealthy banker in Aix-en-Provence, arrived in Paris. His aim, his passion, his most fervent wish was to devote himself body and soul to art. Behind him was a solid classical education received in the college of Aix, rather modest successes (according to his teachers) at the local school of drawing and,

Melting Snow at l'Estaque

1870

Oil on canvas, 72.5 x 92 cm Wildenstein Collection, New York

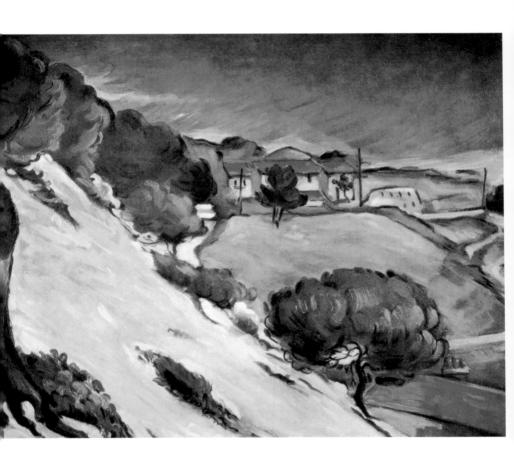

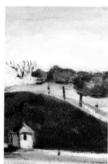

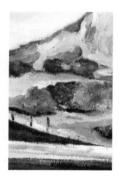

above all, years of rapturous absorption of the unrestrained romanticism of Victor Hugo, Alfred de Musset, and Charles Baudelaire, years of youthful dreaming, together with Émile Zola, of the lofty calling of the artist and of their future collaboration in the field of art.

Trench at the Foot of Mont Sainte-Victoire

1870-1871 Oil on canvas, 80 x 129 cm Neue Staatsgalerie, Munich

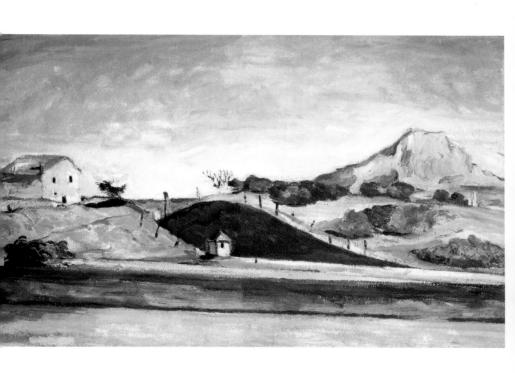

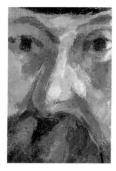

In his first year in Paris, Cézanne evidently still had a certain respect for the acknowledged masters and was willing to join them. During this short period he was at a crossroads; being not fully aware of his talent, he was trying in vain to find himself, and finally returned to Aix,

Self-Portrait with Cap

1872 Oil on canvas, 53 x 39.7 cm Hermitage, St. Petersburg

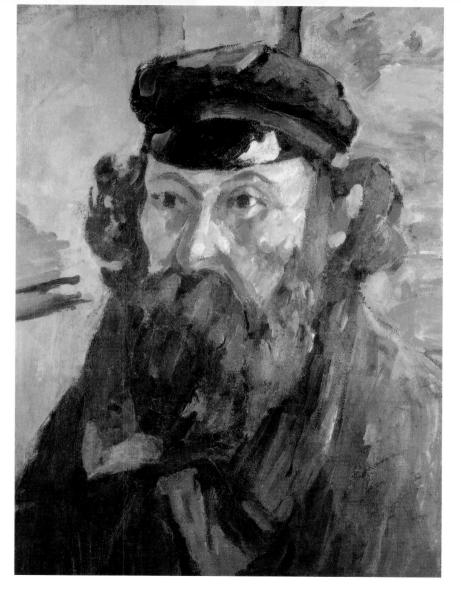

acceding to his father's wishes, to continue the family business. One day he wrote on a page in a ledger: Mon père le banquier ne voit pas sans frémir, Au fond de son comptoir naître un peintre à venir...

The House of Dr. Gachet in Auvers

1872-1873 Oil on canvas, 46 x 38 cm Musée d'Orsay, Paris

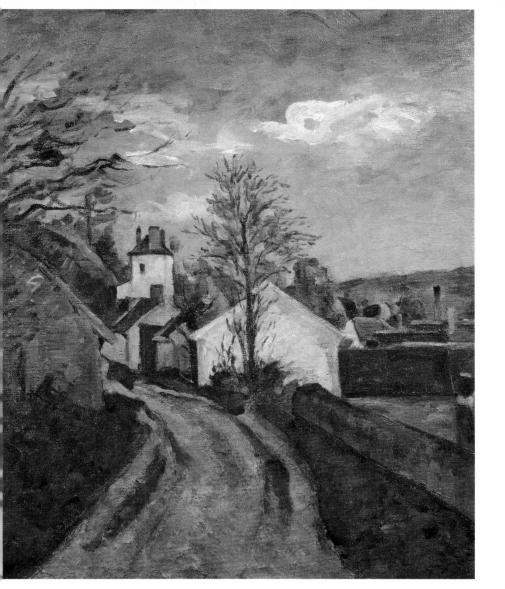

Ultimately Cézanne the banker was obliged to abandon his hopes of making his son a worthy successor to himself in business; granting him a very modest allowance of 250 francs a month, he let Paul go to Paris to devote himself to his consuming passion. There Cézanne took up art in earnest.

The House of the Hanged Man at Auvers

1873 Oil on canvas, 66 x 55 cm Musée d'Orsay, Paris

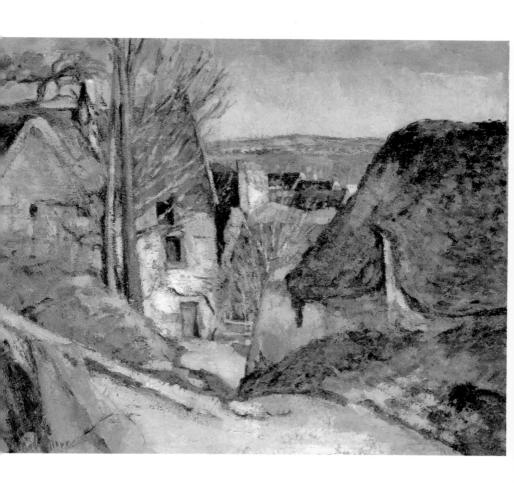

Anxious to obtain a fundamental artistic training, he was preparing to enter the École des Beaux-Arts and worked hard at the Academie Suisse in a desire to improve his technique. He failed the entrance examination for the École des Beaux-Arts, but at the same time found new friends, above all Camille Pissarro, who was to exert a substantial influence on his artistic development.

A Modern Olympia

1873 Oil on canvas, 46 x 55.5 cm Musée d'Orsay, Paris

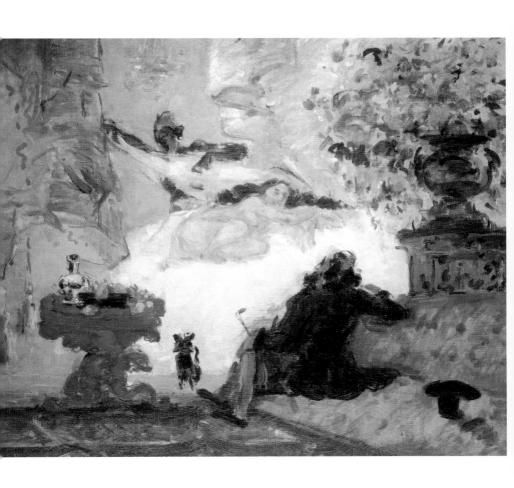

During that first decade, generally considered from the years 1859 to 1870, Cézanne's work was marked by a wealth of themes and experiments. Among the few surviving works of his youth are genre scenes, compositions on religious and mythological subjects, and decorative allegoric panels with which he adorned the walls of the Jas de Bouffan, his parents' estate.

Flowers in a little Delft Vase

c. 1873 Oil on canvas, 41 x 27 cm Musée d'Orsay, Paris

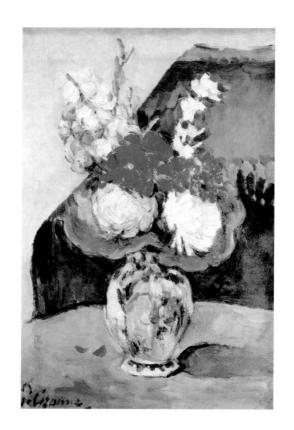

Sometimes these are copies of prints or of pictures from his mother's and sister's fashion magazines. These early works already bear the stamp of the artist's individuality. They reveal his love for powerful, massive forms and simplified light-and-shade relations.

Flowers in a Blue Vase

1873-1875 Oil on canvas, 55.2 x 46 cm Hermitage, St. Petersburg

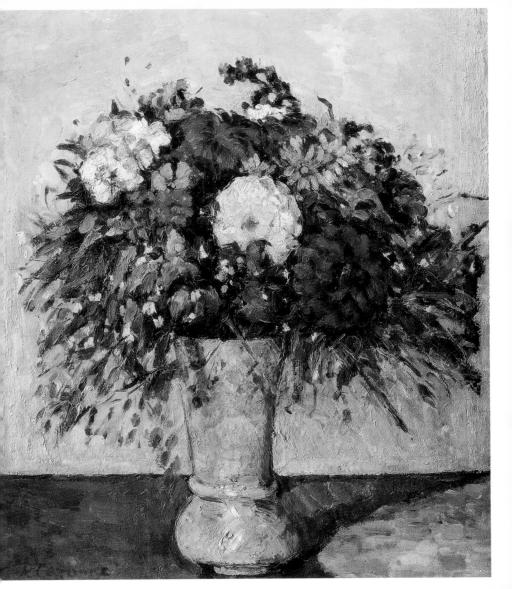

He was in no hurry to follow the Impressionists out of the museum halls and the studio's atmosphere of concentration in order to paint in the open air. He was immersed in an imaginary fantasy world, consumed by the desire to express an irresistible flood of human passion.

Portrait of the Artist

1873-1876 Oil on canvas, 53 x 64 cm Musée d'Orsay, Paris

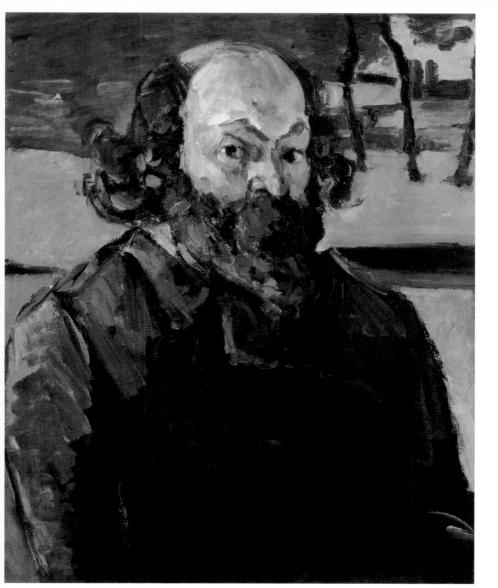

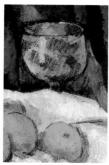

Then, as before, he was attracted, above all, by the art of strong emotions. For an artist with Cézanne's keen sense of the dramatic complexity of the world, a simple representation of the visible was insufficient. He would constantly modify and deform figures, emphasizing in them what he thought to be most important and creating compositions with unstable equilibrium.

The Buffet

1873-1877 Oil on canvas, 65 x 81 cm Szépművészeti Muzeum, Budapest

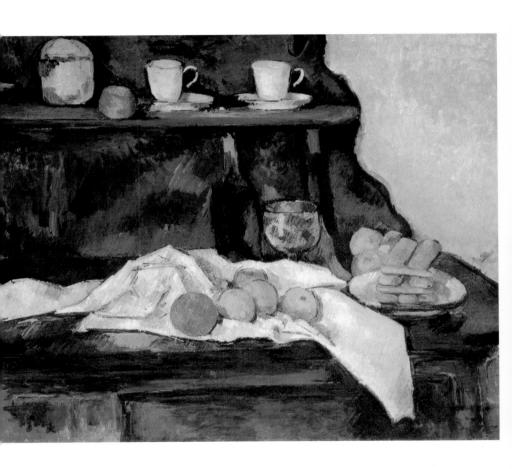

Two Women and Child in an Interior, the earliest of Cézanne's pictures in Russian museums, was executed in the 1860s. Cézanne achieves an effect of depth by the use of a few skillfully arranged objects: a curtain, a small table, and an armchair.

Trees in a Park

1874 Lead pencil, 23.6 x 17.7 cm Graphische Sammlung Albertina, Vienna

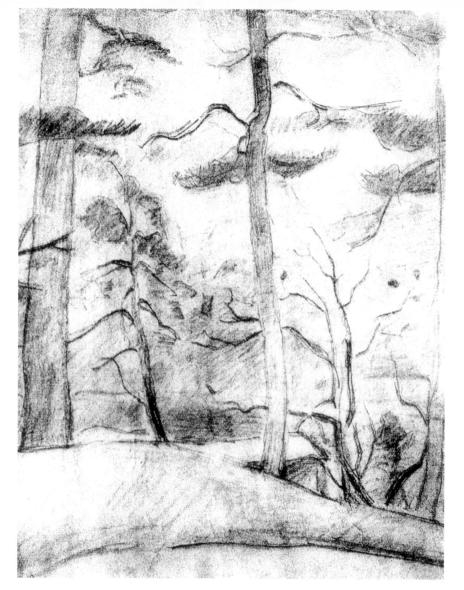

The figures of two women and a girl are grouped around a goldfish bowl. Their poses are thematically not defined, their movements slow, they are absorbed in themselves as if spellbound by the measured movements of the three goldfish in the water.

Auvers, Panoramic View

c. 1874 Oil on canvas, 65.2 x 81.3 The Art Institute of Chicago, Chicago

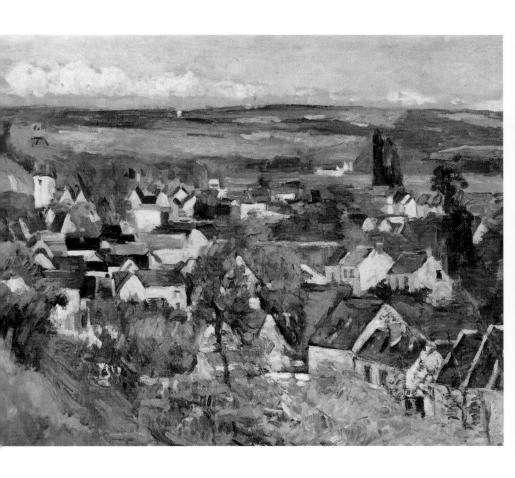

The same dull, dark tone is used for the background, the deep shadows on the objects, and the water in the goldfish bowl. And this creates a sense of one environment, enclosing human beings, fish and objects alike.

Path in Jas de Bouffan

1874-1875 Oil on canvas, 38.1 x 46 cm Tate Gallery, London

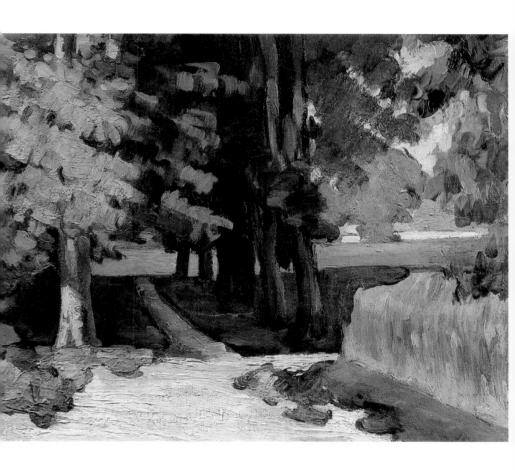

A hypnotizing atmosphere of inner concentration pervades the scene, mutes the sonority of the colors, and slows down the characters' movements, transforming what is in essence an ordinary genre scene into a kind of fantastic dream.

Bathers

1874-1875 Oil on canvas, 38.1 x 46 cm The Metropolitan Museum of Art, New York

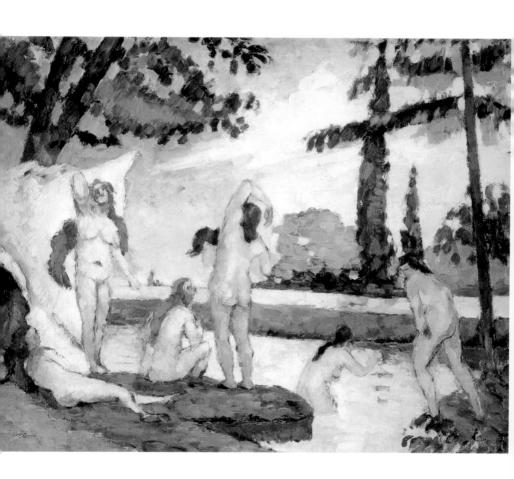

The inner tension, still bound by static forms in *Two Women and Child in an Interior*, is released with tremendous explosive force in other paintings, accompanied by a buildup of color contrasts. Traditional subjects like *Pastoral, Luncheon on the Grass, Fishing*, and others are set in unreal, fantastic surroundings reminiscent of strange, dreamlike visions.

Self-Portrait with a Pink Background

c. 1875 Oil on canvas, 65 x 54 cm Private Collection, Basel

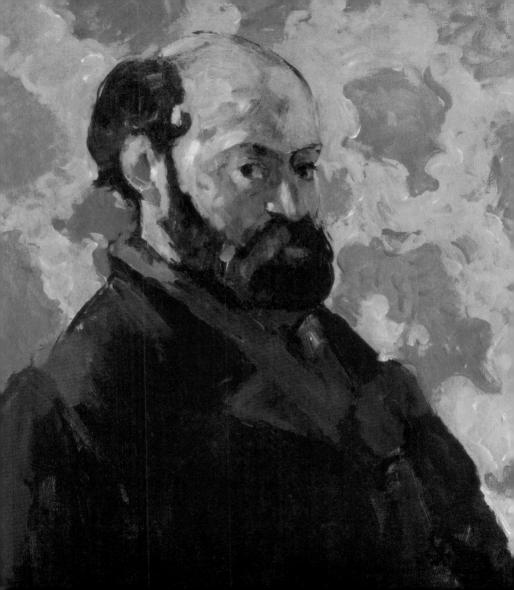

The painting *The Murder* seems to be seen through the eyes of a man stunned by the sight of the murderer's hand raised over his victim. Forms here are generalized in the extreme and are subordinated to a whirlwind of movement: the man's clothes rise corkscrew fashion following the thrust of the hand clutching the knife;

Afternoon in Naples (Rum Punch)

1875 Oil on canvas, 37 x 45 cm National Gallery of Australia, Canberra

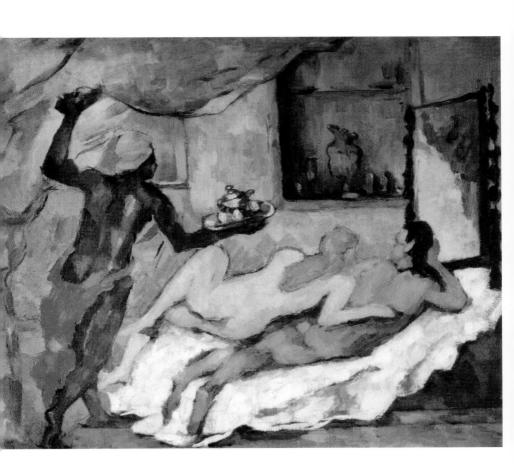

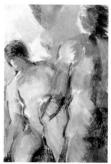

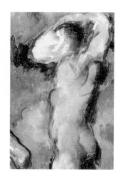

on the right there emerges from the depth a sinister female figure, a kind of chimera, the whole weight of her boulder-like body falling upon the victim; the sharply designated diagonal of the landscape plane recedes into the depths of the painting, and a swirling storm-cloud hangs low over the scene.

Five Bathers

1875-1877 Oil on canvas, 22 x 33 cm Musée d'Orsay, Paris

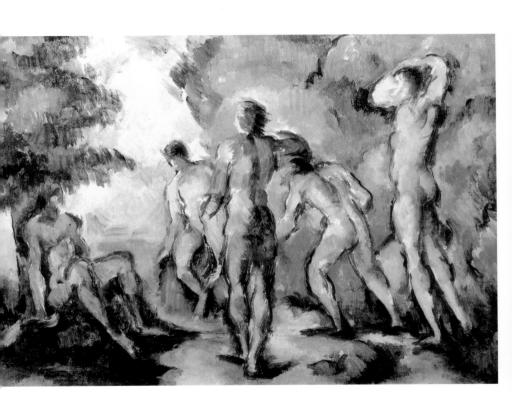

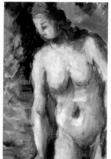

Cézanne put a lot of effort into this composition, as is evidenced by the large number of preparatory drawings. Yet it still looks as if it were painted in a transport of frenzy — the artist applied thick dabs of paint with a palette knife and modeled form with pools of color, striving to truthfully express his own powerful sensations.

Three Bathers

1875-1877 Oil on canvas, 52 x 55 cm Musée du Petit Palais, Paris

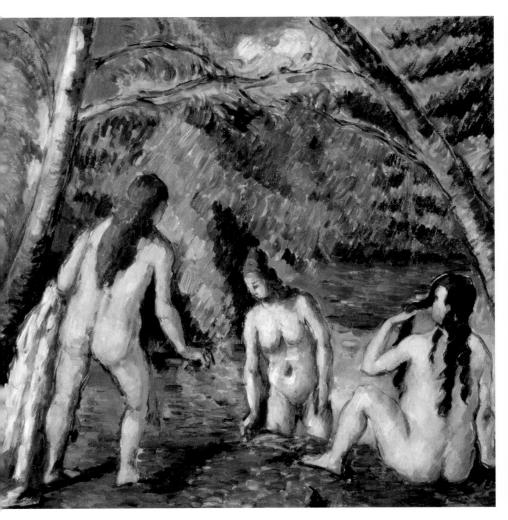

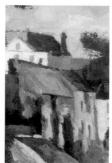

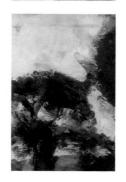

These works were born in the heated imagination of a painter living in provincial bourgeois surroundings, where everything was in opposition to his strivings and hostile to the urgings of his rather prolonged youth.

Road at Pontoise (Clos des Mathurins)

1875-1877 Oil on canvas, 58 x 71 cm Pushkin Museum of Fine Arts, Moscow

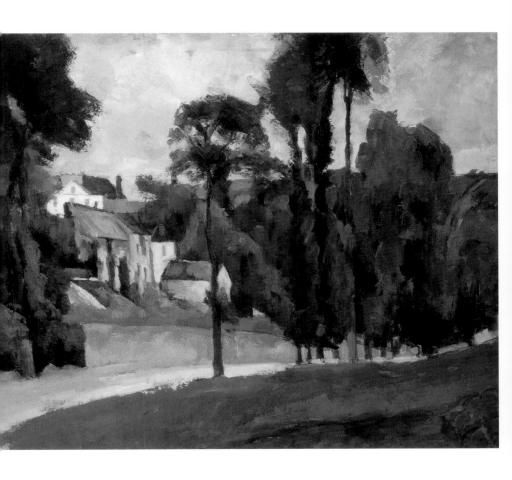

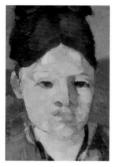

He took up with Hortense Fiquet, a girl not of his social class, but for many years — until 1886 — he was obliged to conceal the liaison and the birth of his son from his father, and to live and keep his family on an irregular pittance.

Madame Cézanne in a Red Armchair (Madame Cézanne in a Striped Skirt)

> c. 1877 Oil on canvas, 72.4 x 55.9 cm Museum of Fine Arts, Boston

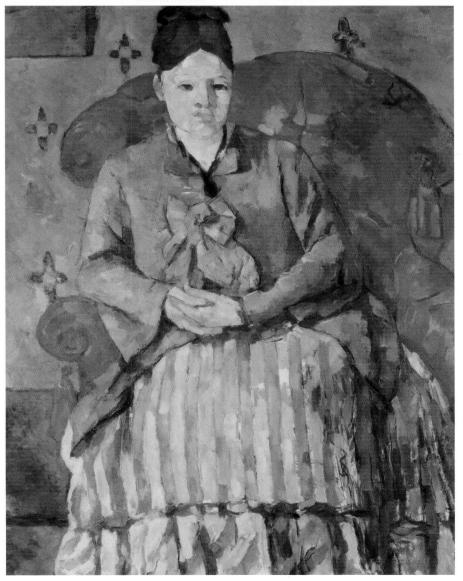

Cézanne's Orgy (1864-1868, private collection), Pastoral (c. 1870, ex-collection of J. Pellerin, Paris), Luncheon on the Grass and many other works painted in the late sixties and early seventies, are permeated with an atmosphere of unreality.

The Eternal Female

c. 1877 Oil on canvas, 43 x 53 cm Private Collection, New York

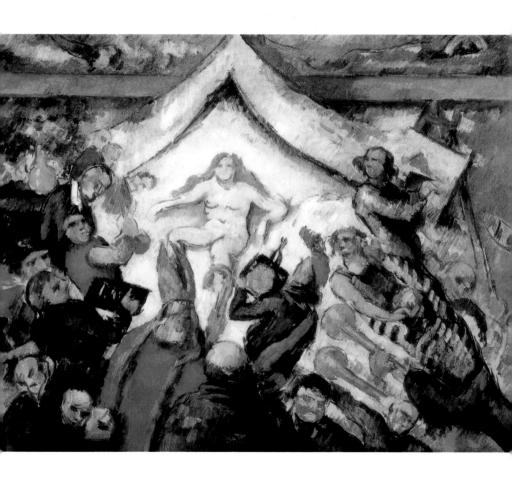

The titles of these pictures are so out of keeping with the traditional idea of the genre that the painter must have chosen them with tongue in cheek. It can be said without fear of error that despite the many influences apparent in these paintings, they are unique in French mid-nineteenth-century art, being the product of the artist's powerful individual vision of the world.

Still Life with a Soup Tureen

1877 Oil on canvas, 82 x 65 cm Musée d'Orsay, Paris

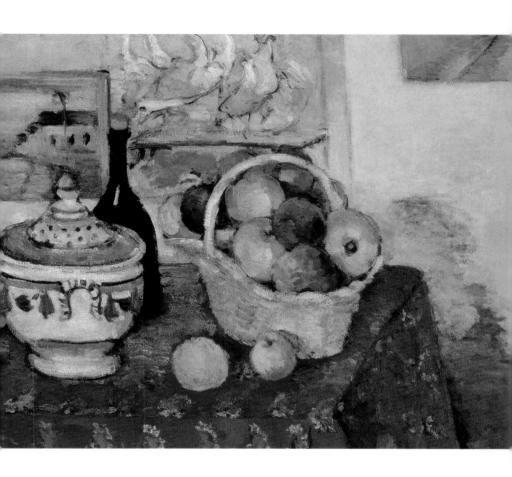

The painting *Uncle Dominique as a Monk* is one of the *Uncle Dominique* series in which the subject is portrayed in one case as a lawyer, in another wearing ordinary indoor clothes, in others in a cap or in fantastic headgear. From the frontal pose in each of these works one can infer that the artist attempted to build up a strongly pronounced relief on the canvas's surface.

Self-Portrait

1877-1880 Oil on canvas, 25.5 x 14.5 cm Musée d'Orsay, Paris

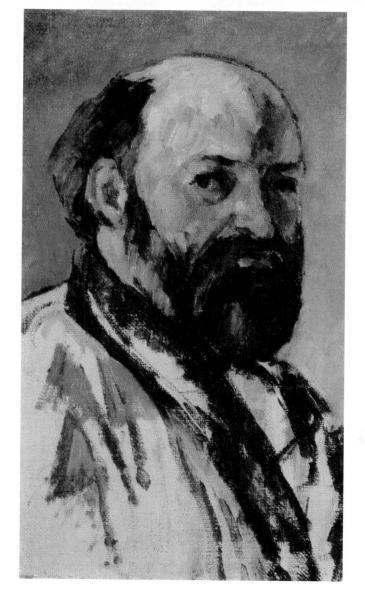

By piling up dabs of paint one upon the other, he created an almost sculptural effect. Obviously, from the very beginning, Cézanne developed a taste for strongly expressed volume, and his painting *Dish of Peaches* (c. 1890-1894, Oskar Reinhart Collection, Switzerland) — a copy of part of a composition by a seventeenth-century Dutch still-life artist, displayed in the Aix municipal museum — may serve as an example.

Bay of Marseille from l'Estaque

1878-1879 Oil on canvas, 55 x 73 cm Musée d'Orsay, Paris

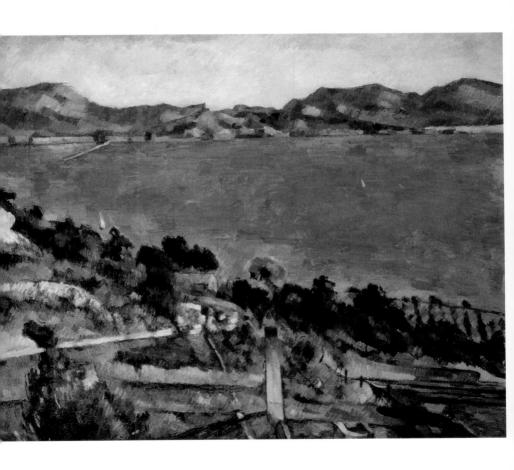

The interest in the interaction of immobility and movement is also evident in the *Portrait* of the Artist's Father (1866–1867, private collection). By slightly moving the figure in relation to the armchair, and the armchair in relation to the wall, the painter has brought all the elements of the picture into a state of instability which, however, is compensated for by the frontal pose of the figure and the implanting of a large newspaper in the hands of Auguste Cézanne.

Fruit

1879 Oil on canvas, 45 x 55.3 cm Hermitage, St Petersburg

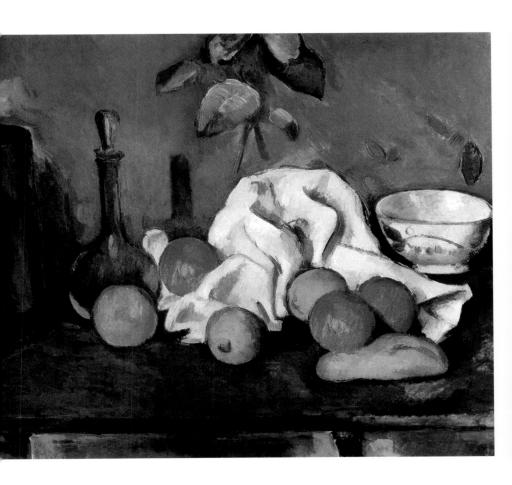

Girl at the Piano is another, more complex work, and the third and only surviving version of Overture to 'Tannhäuser' (1866), so called in tribute to Richard Wagner. The idea of fusing the everyday world with a more elevated one is embodied in the monumental immobility of the figures, the solemn, concentrated calm of their poses, and the measured rhythm of the ornamental pattern calling to mind a musical note or a bass clef as it slowly drifts across the wall.

Bridge in Maincy near Melun

c. 1879 Oil on canvas, 58.5 x 72.5 cm Musée d'Orsay, Paris

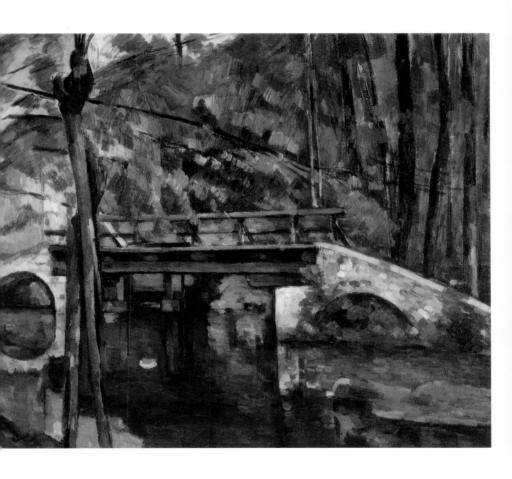

The compositional scheme worked out by the artist lends the scene a special austerity, uniting all the elements and introducing a note of solemnity comparable to that found in medieval icons. Looking at this canvas, one is aware of Cézanne's immense influence on twentieth-century artists.

Fruits

1879 Oil on canvas, 45 x 55.3 cm Hermitage, St. Petersburg

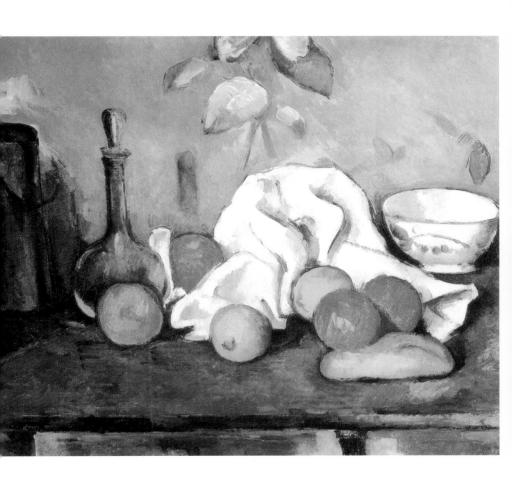

Indeed, the free reconstruction of traditional spatial forms, the violation of established scales, and a synthesized, simplified drawing at which Cézanne arrived by dint of strenuous and intensive experimentation have become a matter of course in twentieth-century art.

Still Life with Dish, Glass and Apples

1879-1880 Oil on canvas, 46 x 55 cm Private Collection, Paris

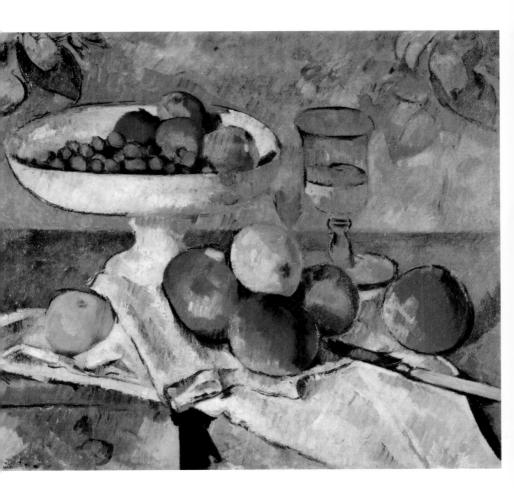

These and a number of other features give Cézanne's work its originality, make it unlike anything done before his time. But Cézanne fully realized the need of mastering the light-and-air medium and to this end was prepared to forego some of his discoveries.

Court of a Farm in Auvers

1879-1880 Oil on canvas, 65 x 54 cm Musée d'Orsay, Paris

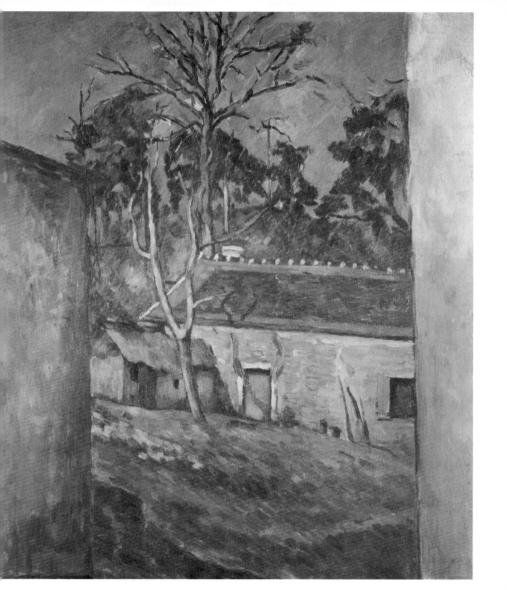

That was one of the reasons why he became close to the Impressionists in the 1870s. Evidence of his first sorties into the outside world is to be seen in his landscapes of the very end of the 1860s. Only in 1872 did he set out to work regularly in the open air.

Apples and Biscuits

1879-1882 Oil on canvas, 46 x 55 cm Musée de l'Orangerie, Paris

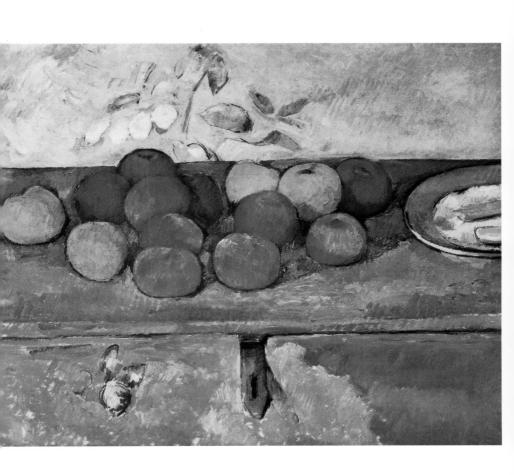

It may be assumed that Pissarro gave some advice to Cézanne, when he settled in Pontoise in 1872 and when a close creative association came into being between the two painters, which continued with minor breaks until 1877.

Pitcher, Fruits and Tablecloth

1879-1882 Oil on canvas, 60 x 73 cm Musée de l'Orangerie, Paris

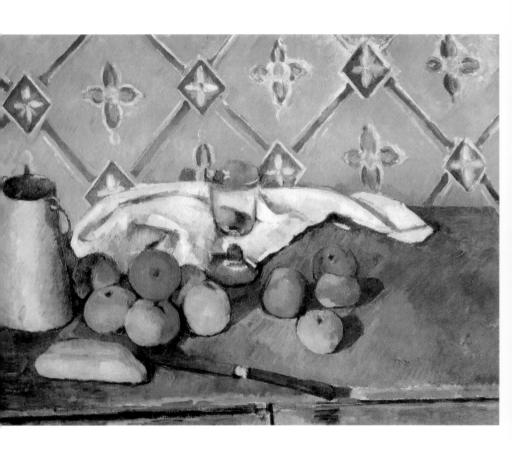

This was the only period of tutelage in Cézanne's life, a period in which he was directly affected by an outside influence, and Pissarro was the only painter of that time who exercised such an influence upon him. They worked side by side on the same motifs, and certain of their pictures of those years bear traces of mutual influence.

Dish of Apples

1879-1882 Oil on canvas, 55 x 74.5 cm Oskar Reinhart Collection, Winterthur

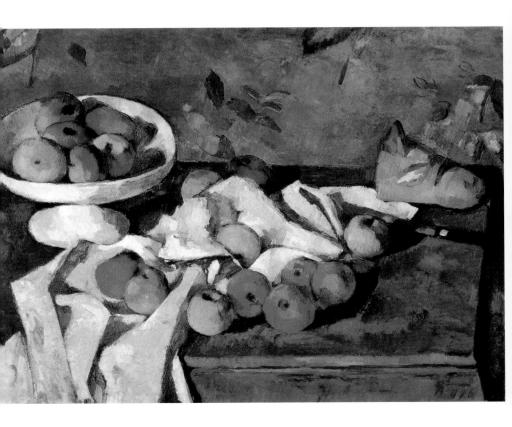

Later Pissarro wrote: "Of course, we were always together; but it is also true that each of us preserved one valuable thing — his own sensation." The first result of this association was a lightening of Cézanne's palette. In his canvas *The House of the Hanged Man at Auvers* (1873, Musée d'Orsay, Paris), the only trace of romanticism was the name which, however, had no direct connection with its subject matter.

Self-Portrait

1879-1882 Oil on canvas, 39.5 x 24.5 cm Private Collection

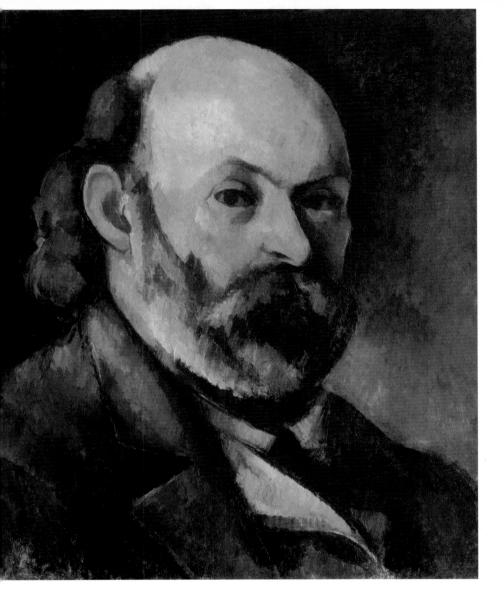

While using light Impressionist tones, Cézanne nevertheless applied the paint thickly. His contact with Pissarro, and through him, with the Impressionists, at a time when the Impressionist trend had reached its zenith, was a turning point in Cézanne's work. Pissarro gave him a method the absence of which he, Cézanne, acutely felt in his early period.

Landscape in Provence

c. 1880 Watercolor, 34.6 x 49.9 cm Kunsthaus Zurich, Zurich

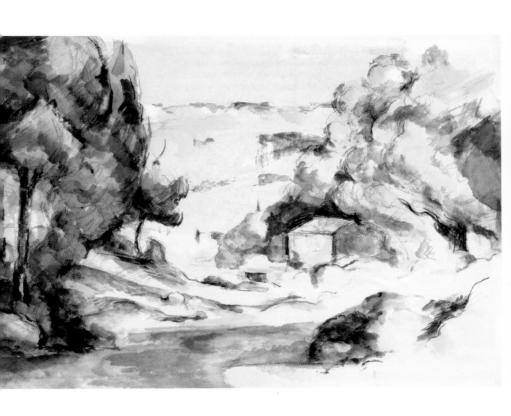

But under Cézanne's brush this method produced unexpected results, for the strivings of Cézanne and those of Pissarro were in many ways dissimilar. Cézanne willingly listened to Pissarro's advice, especially as this mild and patient man had an exceptional gift as a teacher.

Bassin in Jas de Bouffan

1880-1890 Oil on canvas, 64.8 x 81 cm Metropolitan Museum of Art, New York

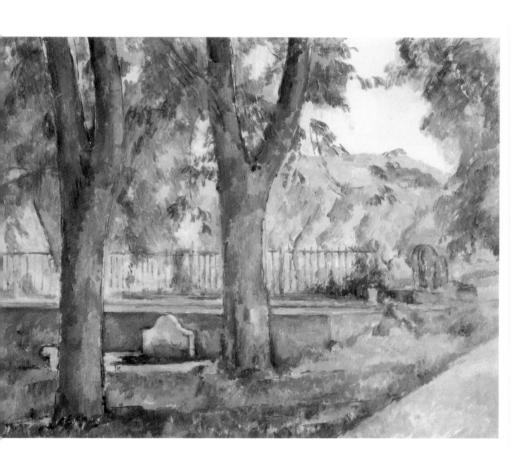

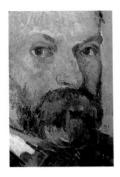

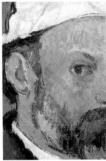

But at the beginning of his Auvers period Cézanne was not equipped to react so speedily to what he perceived. He was used to pondering over a painting. His thick, heavy brushstrokes were not suitable for expressing fleeting atmospheric nuances.

Self-Portrait in a White Hat

1881-1882 Oil on canvas, 55.5 x 46 cm Bayerische Staatsgemäldesammlungen Neue Pinakothek, Munich

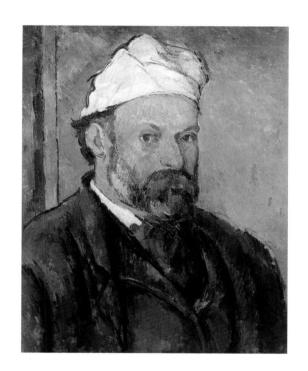

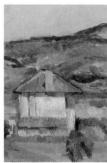

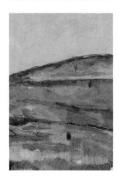

In addition, he was not satisfied with such unconditional dependence on the chromatic range provided by nature. He wanted to find a synthetic solution to all the harmonies offered by nature, and he strove for constructively well-thought-out space in a painting.

Plain by Mont Sainte-Victoire

1882-1885 Oil on canvas, 58 x 72 cm Pushkin Museum of Fine Arts, Moscow

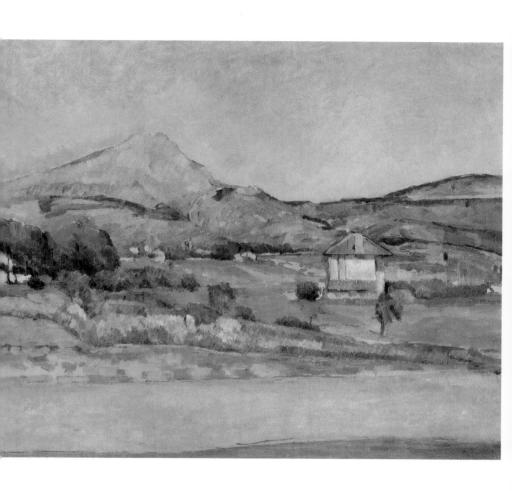

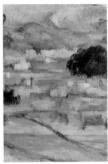

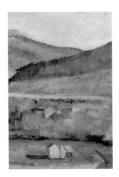

The following dilemma confronted Cézanne: he had either to accept Impressionism with all its wild play of interacting color reflections and shimmering mist of the light and air medium, or he must reject it and, together with it, his new perception of the world. This perception, partly under the influence of Impressionism, was becoming wider, more profound and more acute. Cézanne wavered.

Mont Sainte-Victoire, View from Bellevue

1882-1885 Oil on canvas, 65.4 x 81.6 cm Metropolitan Museum of Art, New York

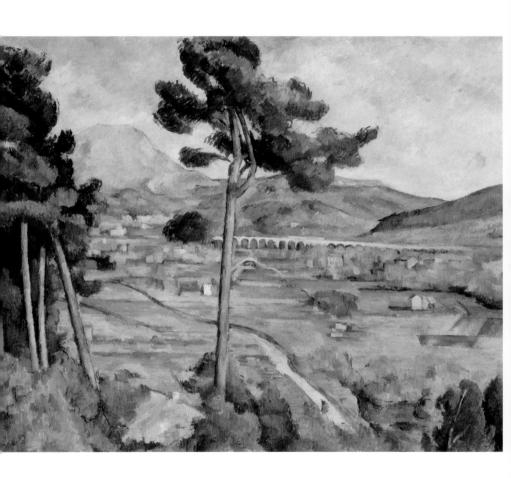

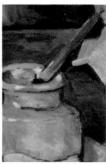

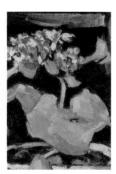

But even in his most Impressionistic works he could never accept entirely the system of painting in tiny, divided brushstrokes which enabled Monet and Pissarro to achieve a sense of the continual changes of air and light. *Road at Pontoise* is an example of Cézanne's version of Impressionism.

Vase of Flowers on a Table

1882-1887 Oil on canvas, 60 x 73 cm Private Collection, Paris

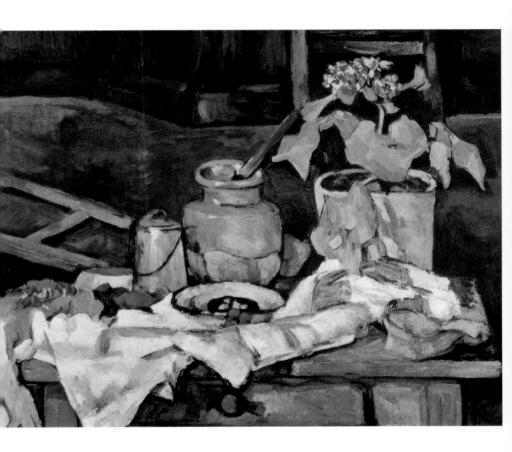

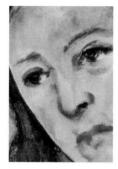

Following Pissarro's advice, he regards the motif first of all "from the point of view of form and color," he "does not fix his eye on one point," does not stress the thematically focal point of a composition — all the elements of a landscape are of equal value in his eyes, and he paints them simultaneously, observing at the same time the reflections of colors on everything that surrounds them.

Portrait of Madame Cézanne

1883-1885 Oil on canvas, 62 x 51 cm Private Collection, Philadelphia

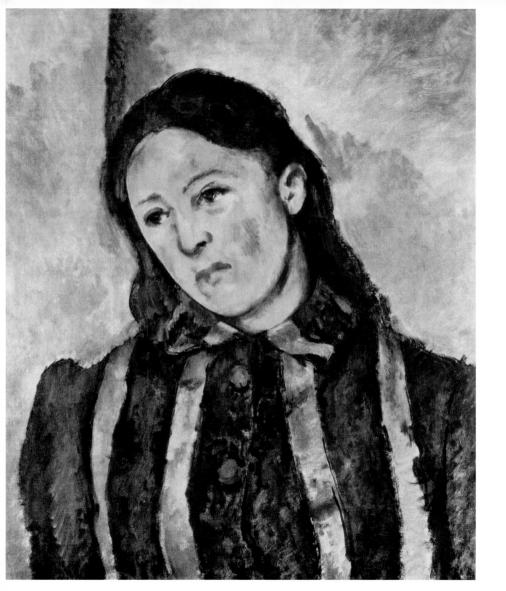

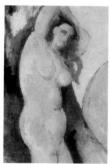

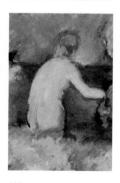

The main problem which Cézanne tackled during this period, whether in landscape, portrait, or still life, was how to achieve the wealth of color reflections revealed by light, while preserving a sense of the material mass and form of objects.

Bathers in Front of a Tent

1883-1885 Oil on canvas, 63.5 x 81 cm Staatsgalerie, Stuttgart

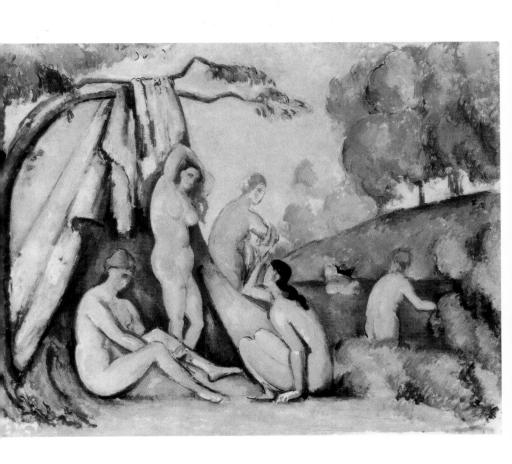

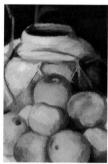

Two of his paintings in the Hermitage demonstrate his searchings along these lines, notably Flowers in a Blue Vase and Self-Portrait in a Cap. In his Flowers in a Blue Vase, Cézanne brings out the form of the objects by his control of the brush

Still Life with a Chest of Drawers

1883-1887 Oil on canvas, 73.3 x 92.2 Bayerische Staatsgemäldesammlungen Neue Pinakothek, Munich

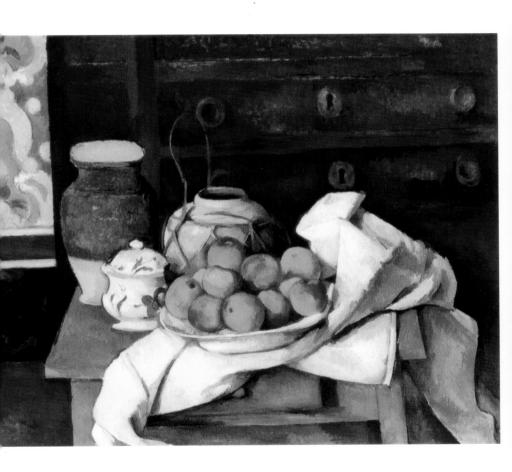

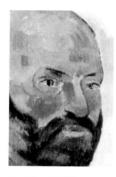

For Cézanne the bouquet is a combination of separate flowers, stems, and leaves. It is first of all a pictorial form, as strict and definite as the very vessel in which it is held. In *Self-Portrait in a Cap*, the face, the clothes, and the cap are treated as a solid color mass of the same texture throughout.

Self-Portrait with Palette

1884

Oil on canvas, 92.5 x 73 cm E.G. Bührle Foundation, Zurich

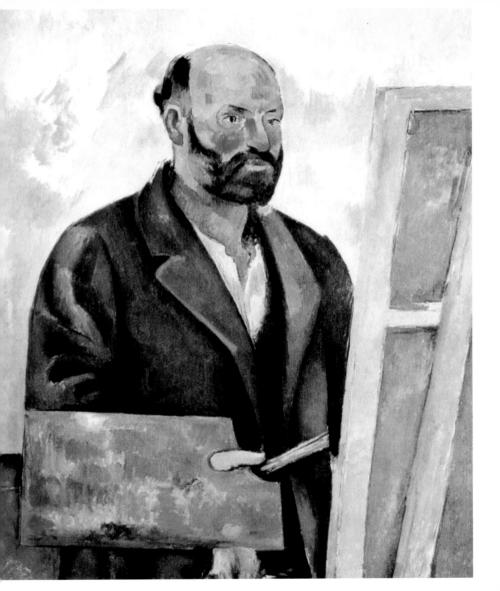

Brushstrokes that are close in tone fuse together to form a single reddish-brown surface on which the green reflections (graduating to violet bluish and blue) create the sensation of natural hollows and recesses filled in with shadow.

Trees and House

1885 Oil on canvas, 54 x 73 cm Musée d'Orsay, Paris

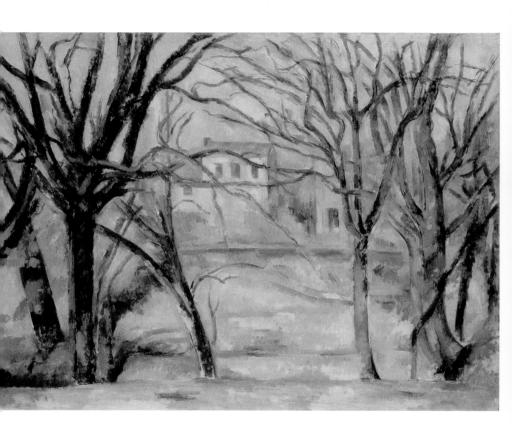

The difference between Cézanne's and Pissarro's methods was inelegantly but precisely defined by a peasant who watched both artists at work: "Monsieur Pissarro, when he is working, pokes, Monsieur Cézanne dabs." The period of Cézanne's closest links with the Impressionists is in the 1870s; he exhibited with them in 1874 and in 1877.

Village in Provence

c. 1885 Oil on canvas, 65 x 81 cm Kunsthalle, Bremen

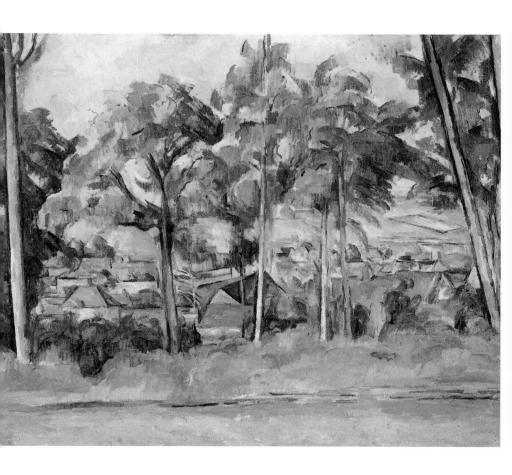

However, by the end of the decade, the artist began to sharply feel the incompatibility of his understanding of a painting with some aspects of the Impressionist method. "I keep on working, but with little success, and it's all too far removed from the general trend..." he wrote in 1878.

The Great Bather

c. 1885

Oil on canvas, 127 x 96.8 cm Museum of Modern Art, New York

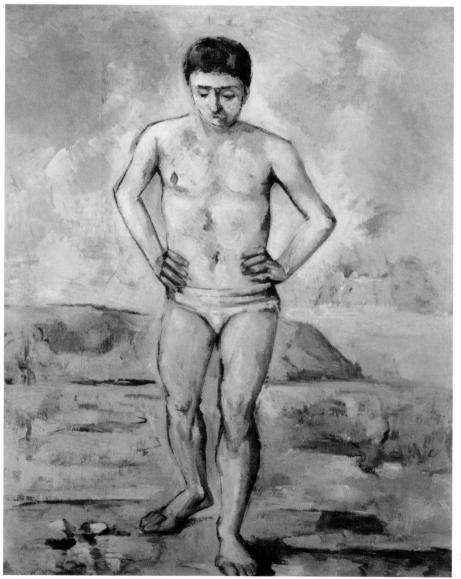

Cézanne gradually moved away from Impressionism, though continued to be on friendly terms with Monet and Pissarro, even going so far as to work with Renoir in the 1880s, but this time on a new basis. Thus, at the end of the 1870s, now almost forty, Cézanne once again finds himself at a crossroads. And the painter sets out on a new quest.

Tall Trees in Jas de Bouffan

1885-1887 Oil on canvas, 64.7 x 79.5 cm Courtauld Institute Galleries, London

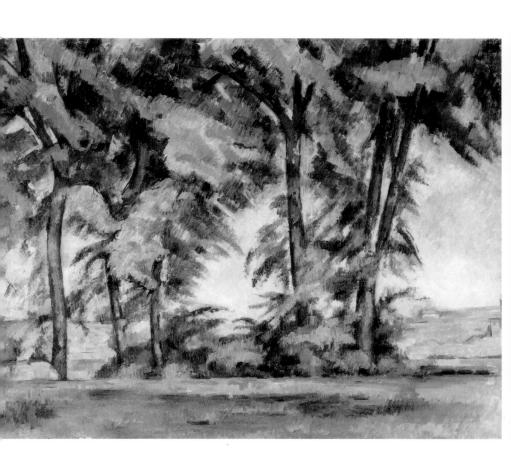

Strictly speaking, Cézanne's work falls into two main stages: before 1873 and afterwards, when the artist started to paint from life and began to master reality, a process which went on day by day until his very death. Cézanne himself formulated his understanding of theory as "tout est en art surtout théorie, développée et appliquée au contact de la nature."

Path of Chestnut Trees in Jas de Bouffan in the Winter

1885-1886 Oil on canvas, 73.8 x 93 cm The Minneapolis Institute of Arts, Minneapolis

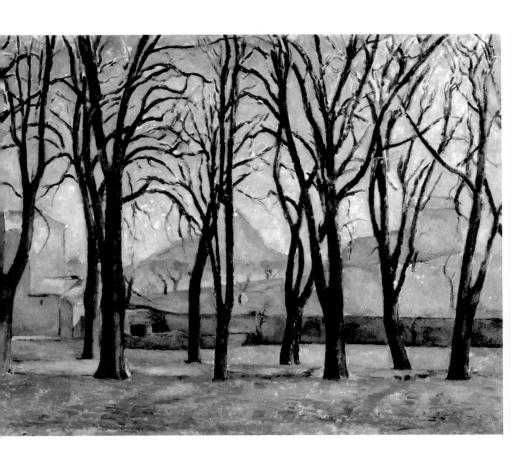

In other words, for him theory was what Émile Bernard called "thinking with brush in hand" about methods of recreating reality. Cézanne did not agree with anything less than portraying nature in accordance with truth and "embracing it as a whole." And if perhaps he too often recognized the impossibility of attaining the unattainable, he did not want to reconcile himself to that and could not bring himself to do so.

Gardanne

1885-1886 Oil on canvas, 92 x 73 cm Brooklyn Museum, Brooklyn

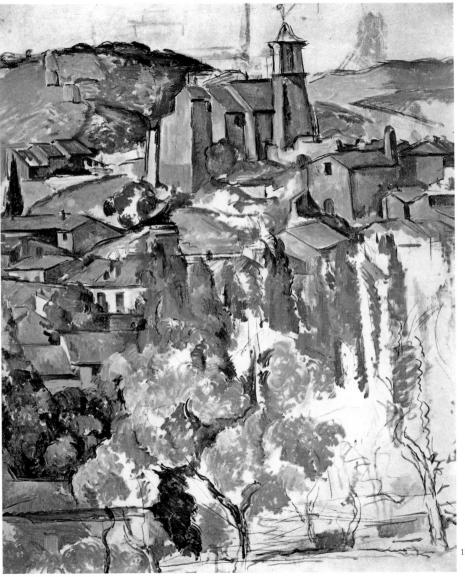

At a certain stage, Cézanne's idea of embracing reality as a whole confronted him with the need to tackle the practical task of maintaining the achievements of the Impressionists, above all in the spatial treatment of light and air, without losing the wealth of objects and colors of reality.

Trees in a Park (The Jas de Bouffan)

1885-1887 Oil on canvas, 72 x 91 cm Pushkin Museum of Fine Arts, Moscow

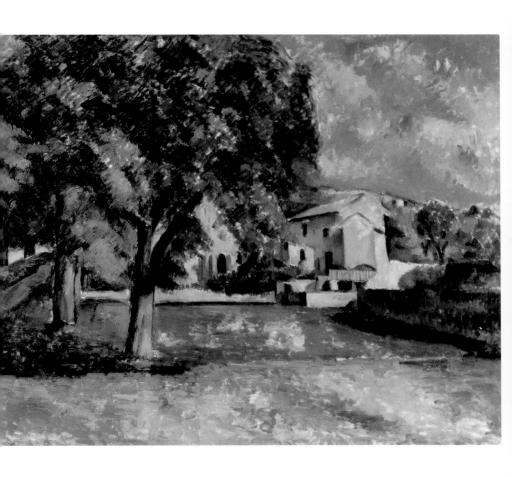

Although in the late 1870s Cézanne and the Impressionists parted company, this did not mean an ideological rupture: their aims and tasks continued to coincide in more respects than one. In his works of the late 1870s, we already see a tendency toward a logical consistency of pictorial means.

The Jas de Bouffan (detail)

1885-1887 Oil on canvas, 72 x 91 cm Pushkin Museum of Fine Arts, Moscow

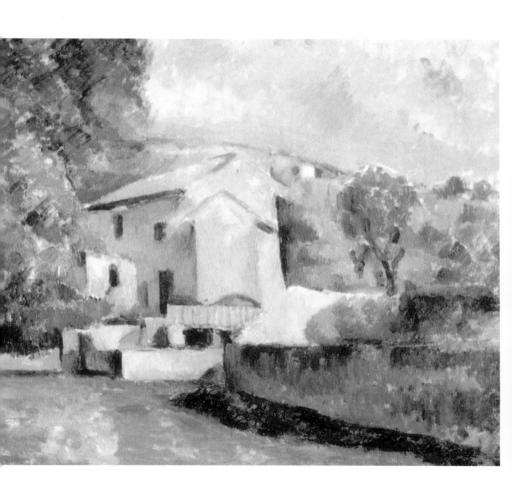

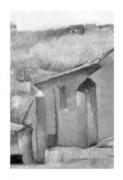

This becomes especially clear if we compare two self-portraits: one painted in the Impressionist period 1873-1875 and the other, executed between 1879 and 1885. In the Hermitage canvas, Cézanne still makes a substantially intuitive use of the law of optical perception, according to which warm tones (pinks and yellows) seem to stand out, to come nearer to us, and cold ones (blues and greens) to recede into the depths.

House and Farm in Jas de Bouffan

1885-1887 Oil on canvas, 60.5 x 73.5 cm Národní Galerie, Prague

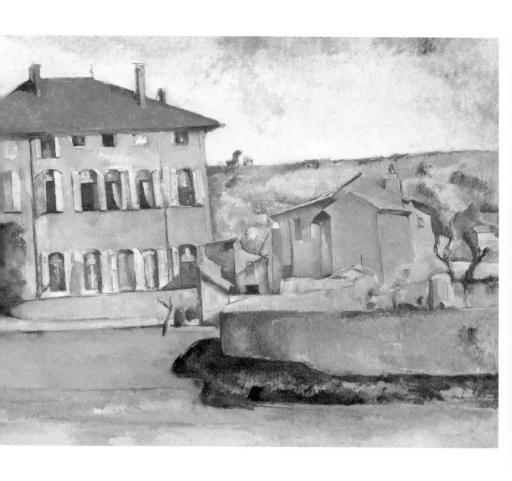

In the Moscow Self-Portrait, these advancing and receding tones are kept under strict, rational control by the artist. The nearer to the periphery, the thicker their layer, the more intensive their dark cold hues. The nearer to the center, the more warm yellowish tones, gradually changing to yellow, orange, and pink colors, begin to show through.

The Aqueduct

1885-1887 Oil on canvas, 91 x 72 cm Pushkin Museum of Fine Arts, Moscow

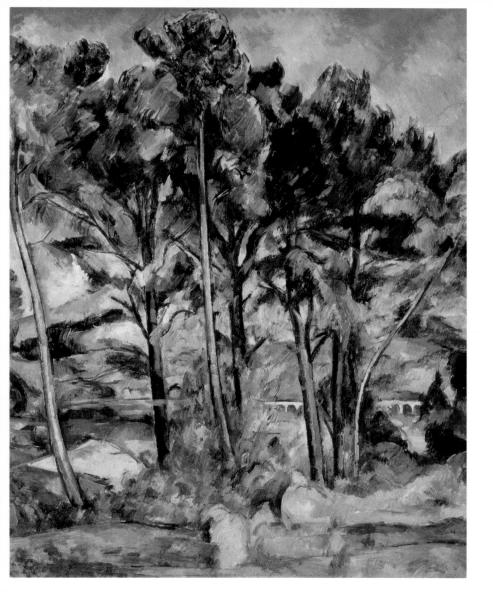

These dabs of paint are not perceived here as color reflections shifting over the surface of the object; they are transformed into certain spatial microplanes used by Cézanne to indicate the extension of form from the surface of the canvas into the depths of the picture.

The Great Pine (Mont Sainte-Victoire)

1886-1887 Oil on canvas, 60 x 73 cm Phillips Collection, Washington DC

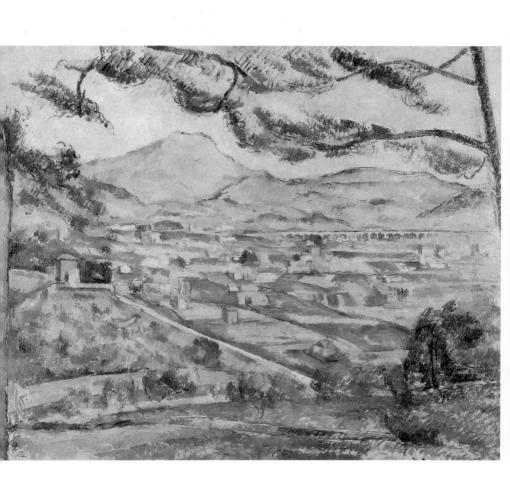

By this method the artist achieves an almost stereoscopic effect: the left-hand side of the face seems to be illuminated and is therefore approaching us, while the right-hand side is plunged in shade, is receding from us, giving the effect of a turning head.

Blue Vase

1885-1887 Oil on canvas, 61 x 50 cm Musée d'Orsay, Paris

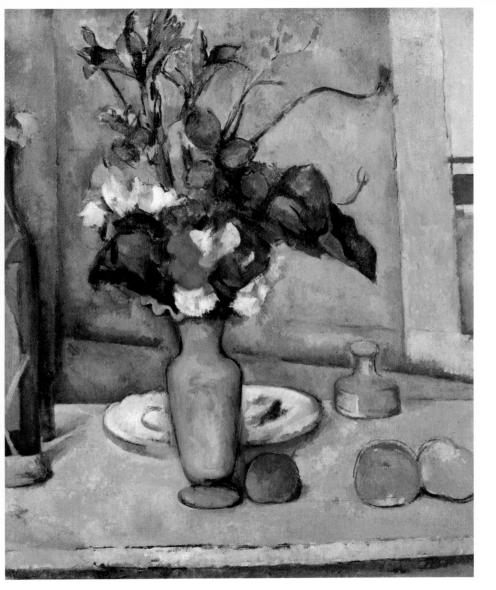

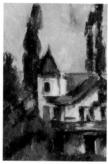

As a result the form takes on a third dimension before our very eyes, demonstrating the unimpeachable logic of its construction. Perhaps there is no other European artist of the past two centuries whose work of still life has occupied so honored a place. This is quite understandable: Cézanne took up this genre as a result of his heightened interest in plastic form.

The Banks of the Marne (Villa on the Bank of a River)

1888 Oil on canvas, 65.5 x 81.3 cm Hermitage, St. Petersburg

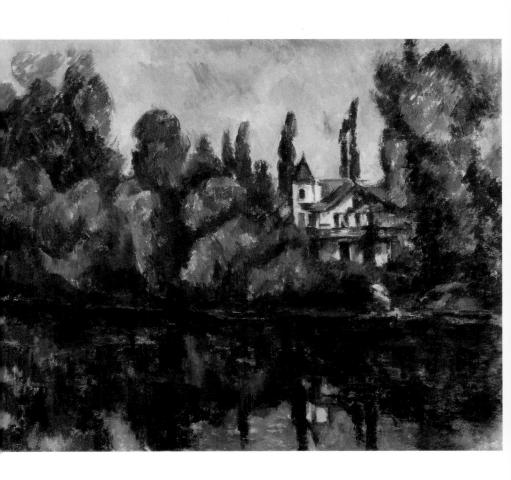

In the 1880s, he produced numerous variations depicting fruit, crockery, vases, and tablecloths, i.e. everything that was stable and unchanging, that could be painted carefully for a long time. The still life *Fruit* is one of a long series of still lifes of this kind.

The Banks of the Marne

1888

Oil on canvas, 71 x 90 cm Pushkine Museum of Fine Arts, Moscow

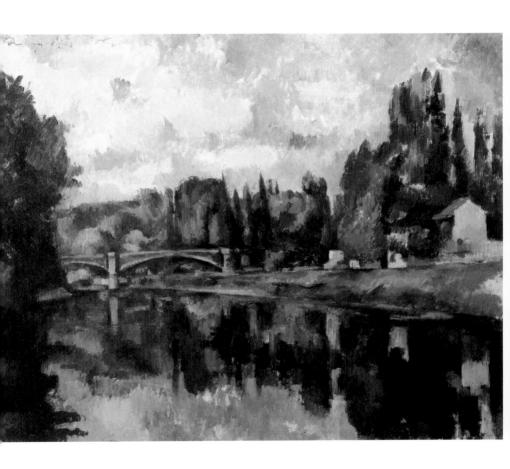

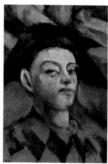

Here we find the same devices as are seen in the Moscow self-portrait: Cézanne builds up the forms of the objects with the aid of warm, advancing tones and cold, receding color planes. As firm as billiard balls, the orange-colored fruits, press down upon the surface of the table with all their perceptible weight, the yellow lemon acquires three dimensions in the greenish shadows at the edges.

Pierrot and Harlequin (Mardi Gras)

1888

Oil on canvas, 102 x 81 cm Pushkin Museum of Fine Arts, Moscow

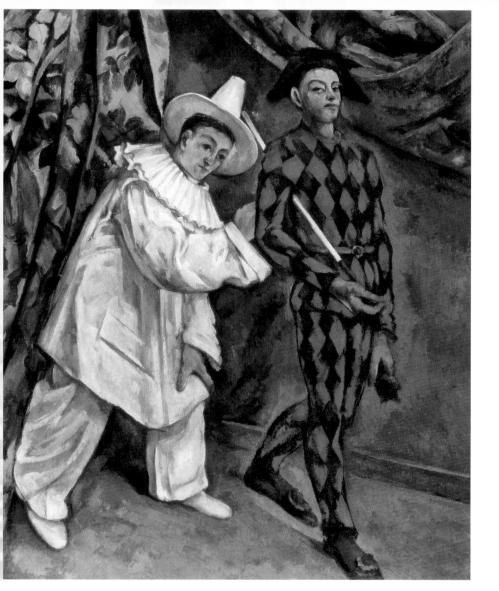

At the center of this composition Cézanne places a tablecloth whose soft, amorphous mass does not link the surrounding objects into a single whole but, on the contrary, emphasizes the autonomous existence of each object in pictorial space. The gleaming fruit do not lose their colorfulness in the darkened part of the picture.

Study for the Painting Mardi Gras

c. 1888
Drawing, black pencil, lead pencil, cream paper, 24.5 x 30.6 cm
Musée d'Orsay, Paris

In this way light ceases to be something external to the object. Subsequently Cézanne's development proceeds in three main directions, those revealing the rich color relations between objects, the relations between their forms and volumes, and between objects and the space in which they exist.

Peaches and Pears

1888-1890 Oil on canvas, 61 x 90 cm Pushkin Museum of Fine Arts, Moscow

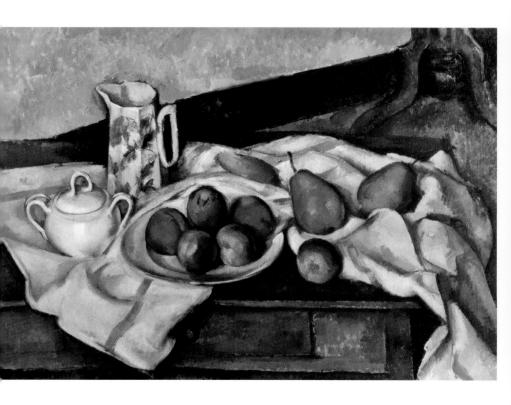

Two still lifes housed in Russian collections, Peaches and Pears (1888–1890, Pushkin Museum of Fine Arts) and Still Life with Curtain, done ten years later, illustrate the stages along this road. In comparison with Fruit, where the contrast between dark and light in parts of the composition still plays a rather significant role,

Bridge and Pool

1888-1890 Oil on canvas, 64 x 79 cm Pushkin Museum of Fine Arts, Moscow

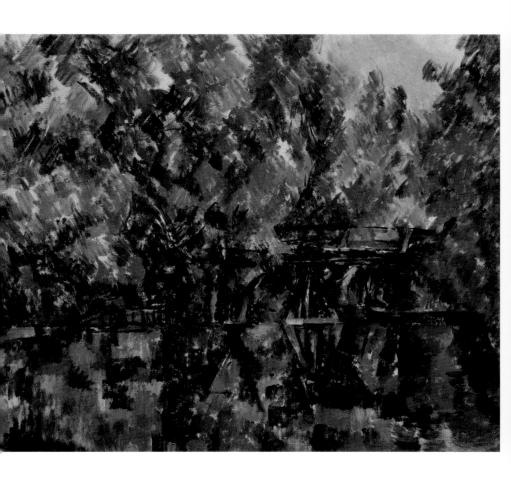

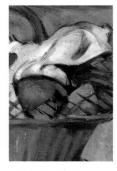

in Peaches and Pears, light has not only ceased to exist as an external source, but it has been transformed into the objects' natural color. In handling pictorial space Cézanne does not reject the principles of classical composition based on singling out the central point and arranging the parts in an equilibrium bordering on symmetry.

Still Life with Basket

1888-1890 Oil on canvas, 65 x 81 cm Musée d'Orsay, Paris

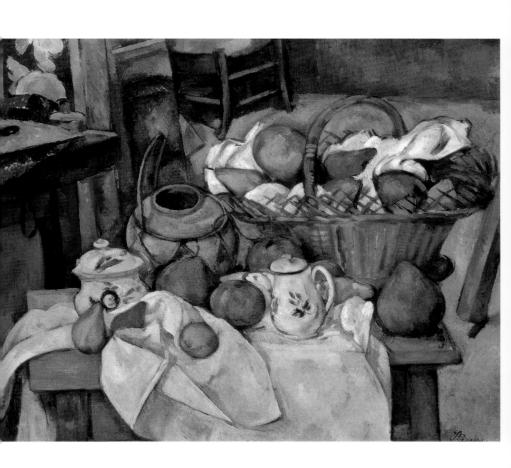

He merely makes these principles more complex, transforms them. The strict order and the complex equilibrium so typical of Cézanne's constructivist period, a period that came to an end about 1890, reign in this painting. One gets quite a different impression from the *Still Life with Curtain* kept in the permanent collection of the Hermitage.

Portrait of Paul Cézanne, Artist's Son with Hat

1888-1890 Oil on canvas, 64.5 x 54 cm National Gallery of Art, Washington DC

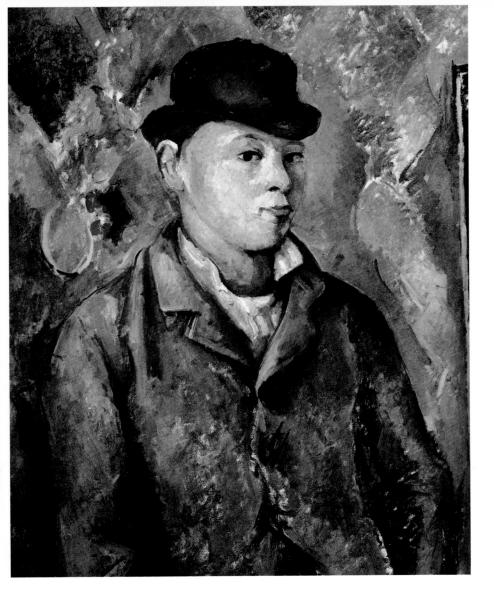

The dishes of fruit are pushed to the side of the viewer, the fruit hang onto the sloping surface by a miracle governed by the laws of pictorial gravity, obviously in contrast to those of Newton. The still life, in which the artist could freely arrange objects, was for him a kind of laboratory in handling space.

Harlequin

1889-1890 Oil on canvas, 92 x 65 cm Rothschild Collection, Cambridge

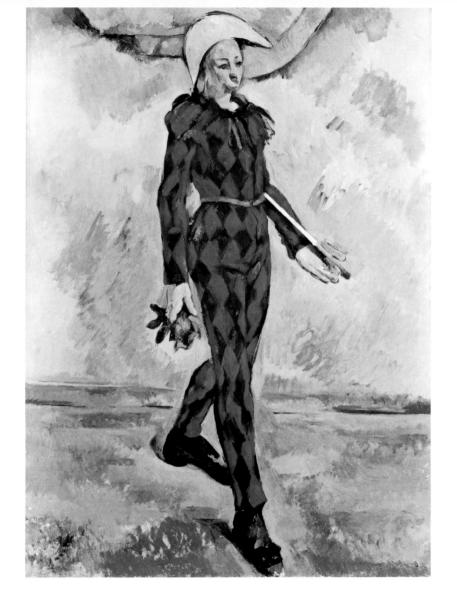

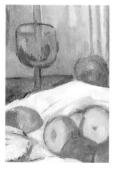

But how can one achieve such integrity in landscape, when the painter, working in the open air, is dependent upon a given space? This problem must have constantly confronted Cézanne. Its complexity was aggravated by the fact that the artist, relying on the visual authenticity of his perception, also tried to express the all-encompassing, synthetic picture of nature that would accord with his keen sense of the world's great cosmic forces.

Dish with Fruits and Drapery

1898-1899

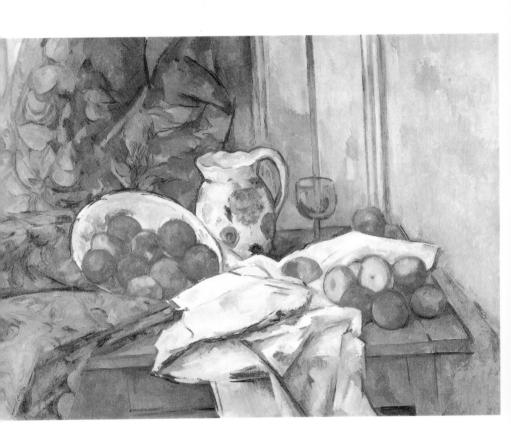

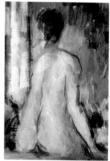

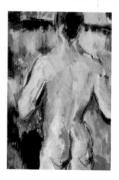

"One is neither too scrupulous nor too sincere nor too submissive to nature; but one is more or less master of one's model and, above all, of the means of expression. Get to the heart of what is before you and continue to express yourself as logically as possible":

Bathers (Study)

early 1890s Oil on canvas, 26 x 40 cm Pushkin Museum of Fine Arts, Moscow

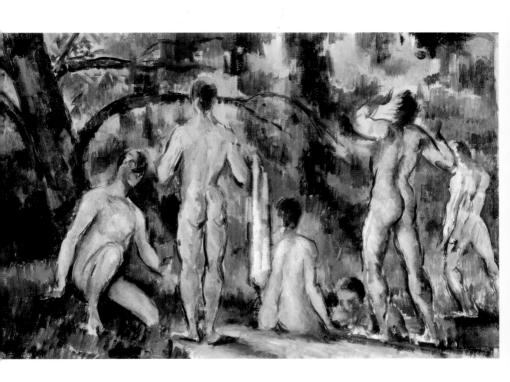

This simple truth expounded by Cézanne was one he scrupulously followed. Landscape always occupied a prominent place in Cézanne's work. But it was only in 1870–1871, during his pre-Impressionist period, when for the first time he turned to the images of L'Estaque and Mont Sainte-Victoire at Aix, that the first signs of a new orientation appeared in his landscapes.

Bathers

1890-1892 Oil on canvas, 60 x 82 cm Musée d'Orsay, Paris

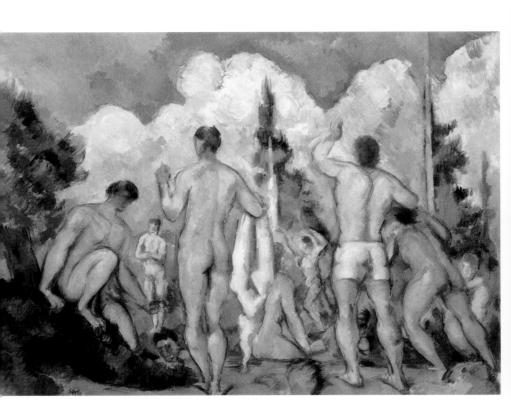

Melting Snow at L'Estaque and Trench at the Foot of Mont Sainte-Victoire (Neue Pinakothek, Munich) are paintings in which two types of Cézanne's landscape compositions can be discerned — the "baroque," with a dynamic diagonal structure (Melting Snow at L'Estaque), and the classical, with an alternation of canvas-wide parallel color zones (Trench at the Foot of Mont Sainte-Victoire).

Man Smoking a Pipe

1890-1892 Oil on canvas, 73 x 60 cm Courtauld Institute Galleries, London

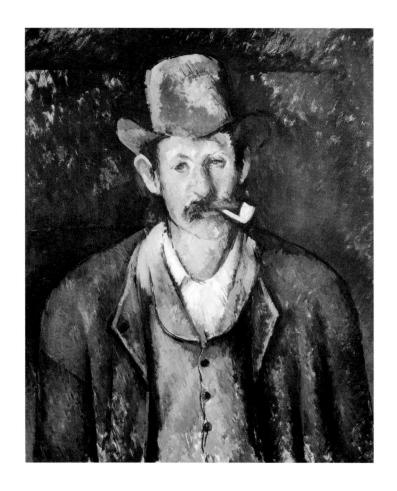

These two canvases are of course merely early experiments; they lack observation of nature and there is no aerial medium what-so-ever. But here one can already see Cézanne's grasp of great spaces and his synthetic image of nature. Plain by Mont Sainte-Victoire (1882–1885, Pushkin Museum of Fine Arts) has some compositional similarity with the Trench.

The Smoker

1890-1892 Oil on canvas, 92.5 x 73.5 cm Hermitage, St. Petersburg

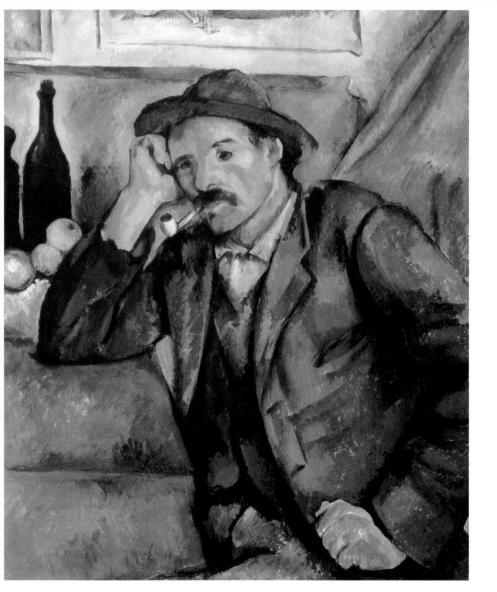

But how far the artist has departed from the former image, how complicated space has become in this, at first glance elementary, compositional scheme. The artist leads the viewer's eye to the mountain by means of parallel color zones that imperceptibly taper off into radii.

The House in Bellevue

1890-1894 Oil on canvas, 60 x 73 cm Private Collection, Geneva

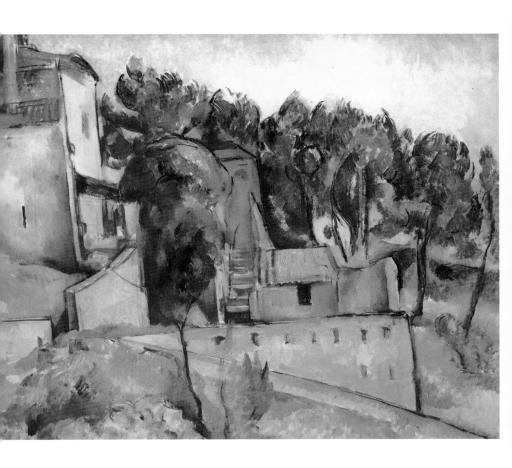

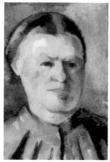

The compositional scheme of *Trees in a Park* (1885–1887, Pushkin Museum of Fine Arts) also has an affinity with the traditional. Nineteenth-century artists often turned to the so-called *sousbois* method of composition, conveying a sense of depth through a barrier of trees. In *Trees in a Park*, the trees predominate, absorbing into their orbit everything around them.

Woman with a Coffee Pot

1890-1895 Oil on canvas, 130.5 x 96.5 cm Musée d'Orsay, Paris

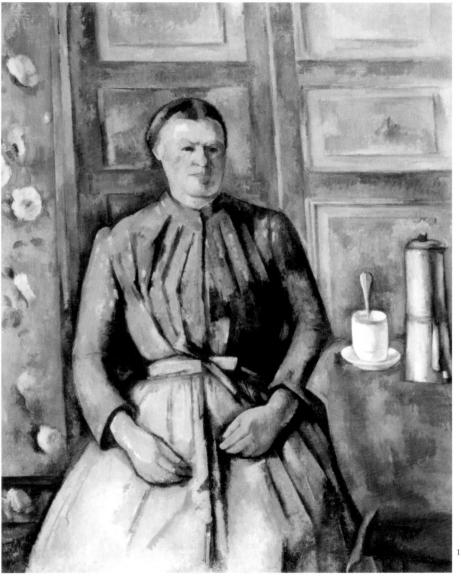

To a certain extent this disguises Cézanne's unconventional understanding of depth. Cézanne reorganizes relations between all objects, violating scale, creating the effect of depth and immediately breaking it down by plunging into inverse perspective. Therefore, objects in the background seem remote and near, and the space of the earth both flat and deep.

Still Life with Bottles and Apples

1890-1894 Oil on canvas, 50.5 x 52.5 cm Stedelijk Museum, Amsterdam

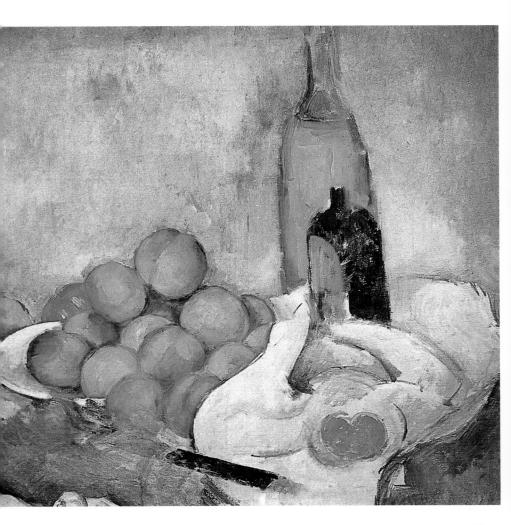

From one landscape to another Cézanne experimented in object and spatial relations. In his *The Aqueduct* (1885–1887, Pushkin Museum of Fine Arts), the narrow space of the foreground consists of large green and orange patches, and a row of pines with their boughs raised to the sky is aligned immediately beyond it. But Cézanne eliminates the material differences between spatial planes.

Bathers

1890-1900 Oil on canvas, 22 x 33.5 cm Musée d'Orsay, Paris

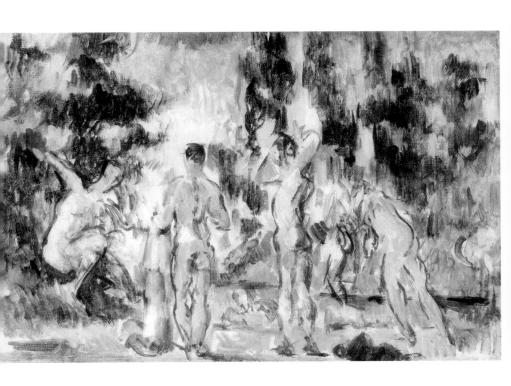

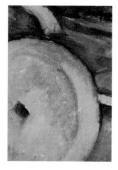

The whirling green brushstrokes model the resilient crowns of the trees, while in the center of the canvas, where the pines cut across the line of the hill on the horizon, these strokes, without losing their specific texture, absorb the bluish-violet tones of the mountain separated from the trees by an immense distance, as if shreds of thickened space, filled with air, are caught between the spreading branches and cannot disengage themselves.

Millstone

1892-1894 Oil on canvas, 73.5 x 92 cm Philadelphia Museum of Art, Philadelphia

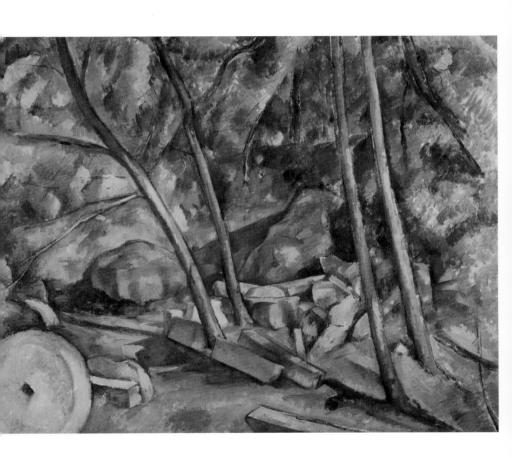

It was in landscapes of this type that the essential aspects of Cézanne's artistic system were realized. In them he shifts planes, intermingles the far and the near, yet preserves a distinct sense of three-dimensionality of space receding into the depths.

Rocks in the Woods

c. 1893 Oil on canvas, 51 x 61.5 cm Kunsthaus Zurich, Zurich

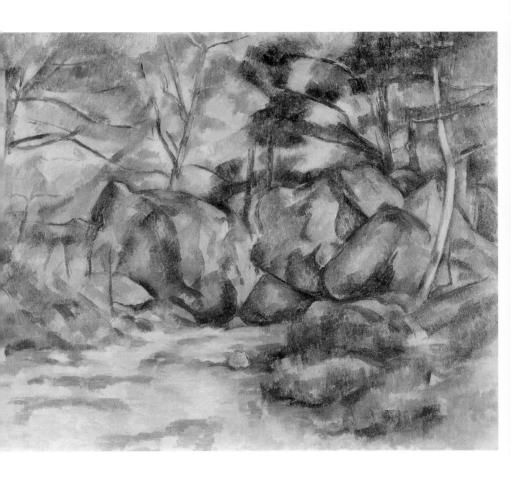

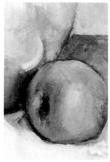

In this way, and this perhaps is the most important feature, Cézanne consistently avoids indicating the precise place from which he looks at the surrounding environment. It is virtually impossible to define the vantage point from which Cézanne's landscapes were viewed and painted.

Pitcher and Fruits

1893-1894 Oil on canvas, 42.2 x 62.8 cm Berggruen Collection, Paris

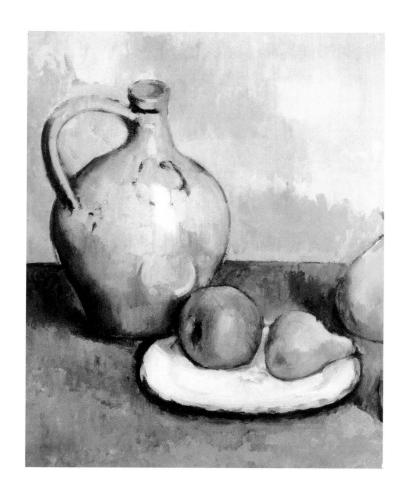

Cézanne's work from the late seventies to the late eighties is usually termed his Constructivist period because of his strictly logical method, rational composition, and so on. These principles determine the style of his portraits, still lifes, and landscapes painted at the time. Perhaps they are most evident in his figure compositions.

A Bottle of Peppermint

1894 Oil on canvas, 65.9 x 82.1 cm National Gallery of Art, Washington DC

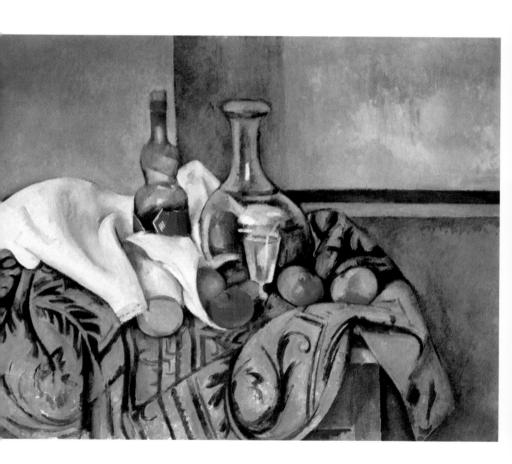

In 1888, simultaneously with *The Banks of the Marne River* Cézanne created another masterpiece, *Pierrot and Harlequin (Mardi Gras,* 1888, E.G.Buhrle Collection, Switzerland), in which he depicted the traditional characters of the French folk theater (1888, Pushkin Museum of Fine Arts).

View of the Château Noir

1894-1895 Oil on canvas, 73.5 x 92.5 cm Oskar Reinhart Collection, Winterthur

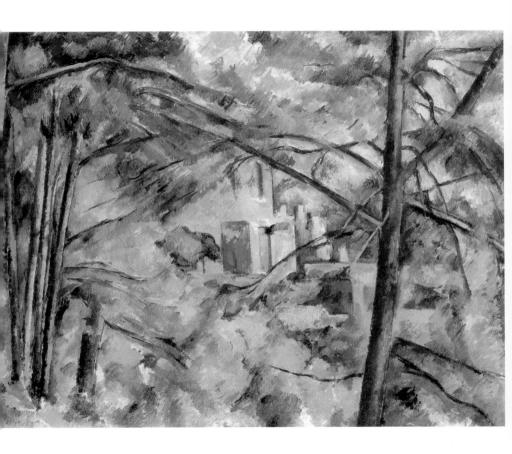

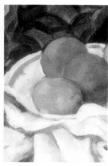

There is no denying that Cézanne's interpretation of the images is traditional, but instead of the usual burlesque clownery, he creates something different. He avoids everything that might seem transient — a spontaneous gesture or fleeting smile. He precludes the slightest possibility of an accidental turn of figure, marking a transition from one movement to another.

Still Life with Curtain

1895

Oil on canvas, 55 x 74.5 cm Hermitage, St. Petersburg

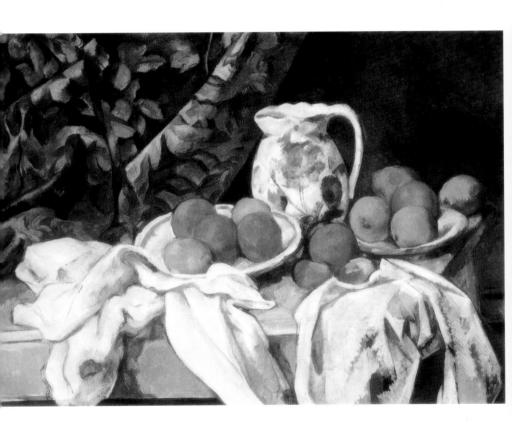

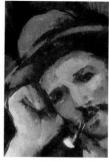

In 1886, a change in Cézanne's fortunes occurred. His father died, leaving him the house at Aix, the villa Jas de Bouffan, and a substantial legacy to him and his sisters. Shortly before this Cézanne had married Hortense Fiquet. At last, he was freed of constant financial problems and everyday worries.

Man Smoking a Pipe

1895-1900 Oil on canvas, 91 x 72 cm Pushkin Museum of Fine Arts, Moscow

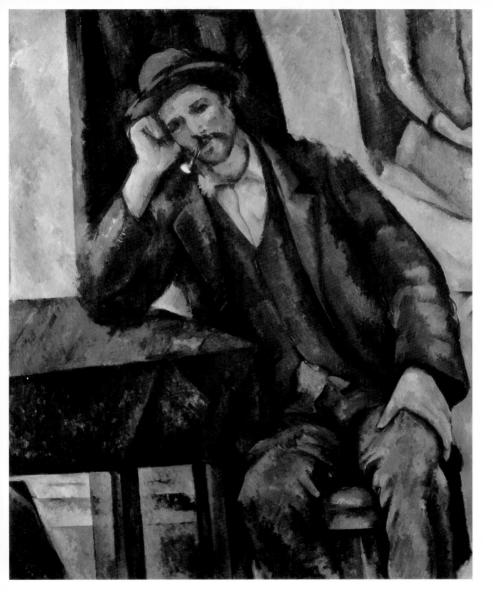

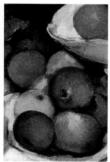

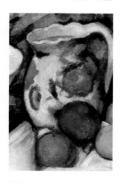

Up to that time the jury had only once, in 1882, admitted one of his paintings into the Salon, and that only on the insistence of his friend Antoine Guillemet, while those works which were occasionally displayed at unofficial exhibitions met with furious onslaughts by critics and the public alike.

Apples and Oranges

1895-1900 Oil on canvas, 74 x 93 cm Musée d'Orsay, Paris

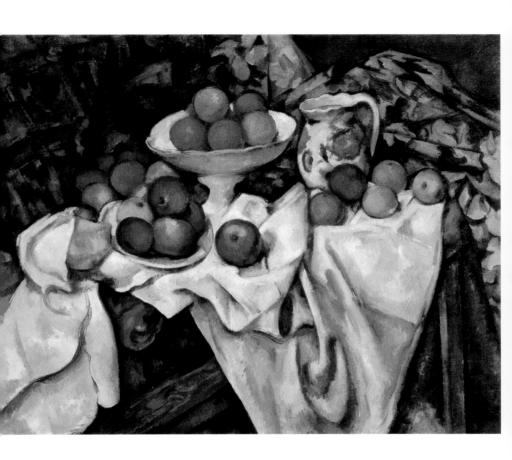

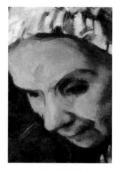

The blows of fate only spurred Cézanne on to harder work. From the beginning of the nineties up to his death he lived almost without a break at Aix, traveling occasionally to Paris to visit his family. Regularly every morning Cézanne would set off to paint. He executed landscapes, portraits, and still lifes.

The Old Woman with a Rosary

1896 Oil on canvas, 80.6 x 65.5 cm National Gallery, London

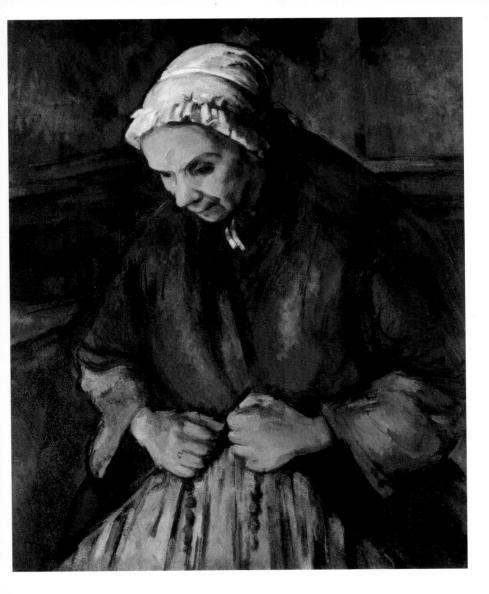

In his studio or at home he painted peasants who posed for him for long periods, retaining throughout their unhurried manner, immobility, and patience — qualities his more intellectual models could seldom attain. This was how he painted his *Card Players* series (1890–1892), the finest example of which is in the Musée d'Orsay in Paris.

Great Pine near Aix

late 1890s Oil on canvas, 72 x 91 cm Hermitage, St. Petersburg

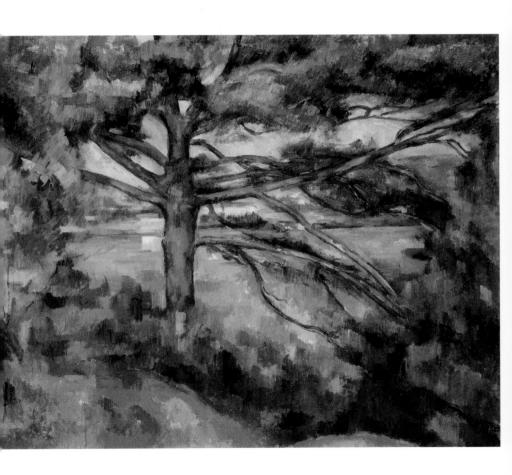

Here two figures and the details of the interior are incorporated into a rigid compositional scheme. If in the mind's eye one prolongs the inclinations of the figures of the two players, and the lines of their hands, then a distinct rhomboid is formed, the apexes of which lie outside the canvas; at the same time the bottle in the center of the composition divides the rhomboid vertically, and the rear edge of the table horizontally.

The Lake at Annecy

1896 Oil on canvas, 64 x 81.3 cm Courtauld Institute Galleries, London

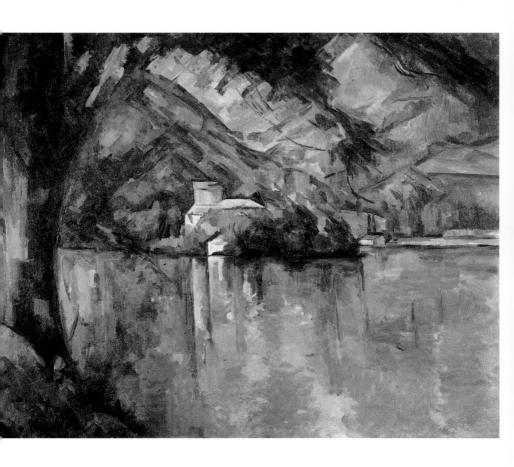

This constructivist logic gives the composition a surprising stability and imparts a monumental quality to the images of the peasants. Two paintings in Russian collections are executed in the same way: *The Smoker* (Hermitage), and *Man Smoking a Pipe*, both dated 1895–1900.

Mont Sainte-Victoire

1896-1898 Oil on canvas, 78 x 99 cm Hermitage, St. Petersburg

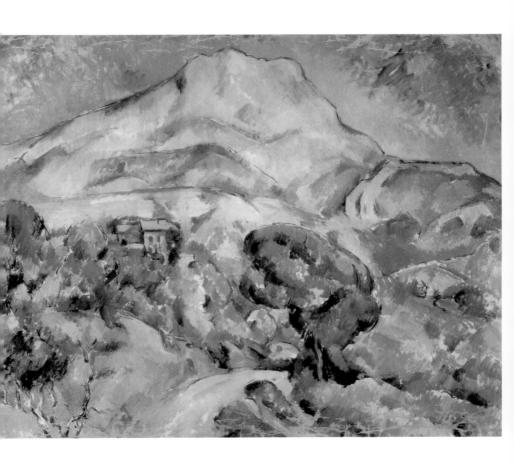

One would have thought that toward the end of the 1880s Cézanne was achieving his desire: he transformed Impressionism into "something solid and durable, like the art of the museums." In place of the fragmentary character of an Impressionist painting,

Mont Sainte-Victoire, View from Bibémus

c. 1897 Oil on canvas, 65 x 80 cm Museum of Art, Baltimore

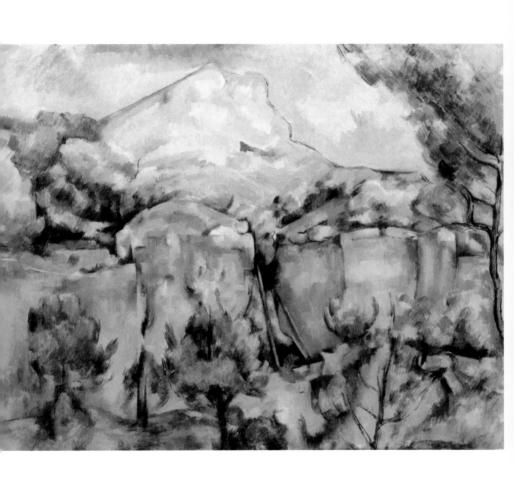

Cézanne asserted the composition structured according to classical laws. In place of the fleeting nature of atmospheric and psychological states came Cézannesque stability, based on an equilibrium between immobility and movement. Evidently, this too could not completely satisfy the artist whose main aim was to "embrace reality as a whole."

In the Park of the Château Noir

1898 Oil on canvas, 92 x 73 cm Musée de l'Orangerie, Paris

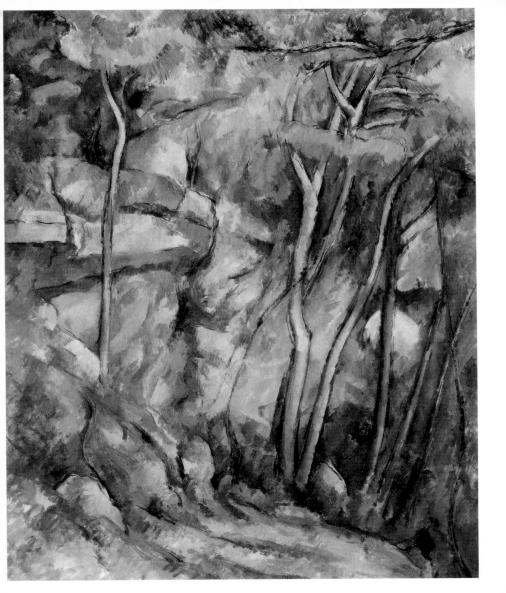

In his later years, Cézanne experienced a re-awakening of the sensations of his romantic youth — sensations of the intense and dynamic life of the universe. To him the realization of this meant the coupling of one more, and now last, link to his system of embodying reality;

Bibémus Quarry

1898-1900 Oil on canvas, 65 x 81 cm Folkwang Museum, Essen

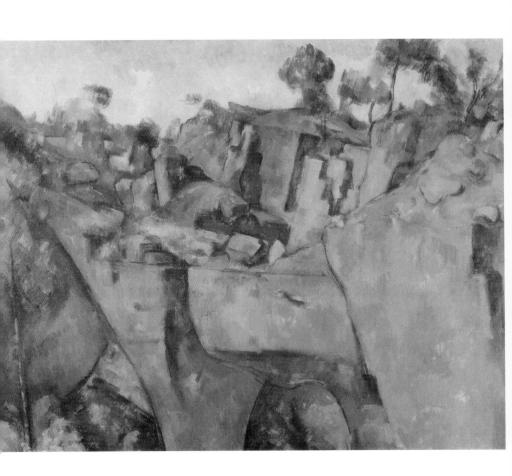

it meant setting down on the immobile surface of the canvas the motion of formative rhythms and processes of life as they come into being, at the same time preserving the material stability of natural forms. It was a formidable task which necessitated a reassessment of all his old ideas.

In the Park of the Château Noir

1900 Oil on canvas, 94 x 74 cm Musée Picasso, Paris

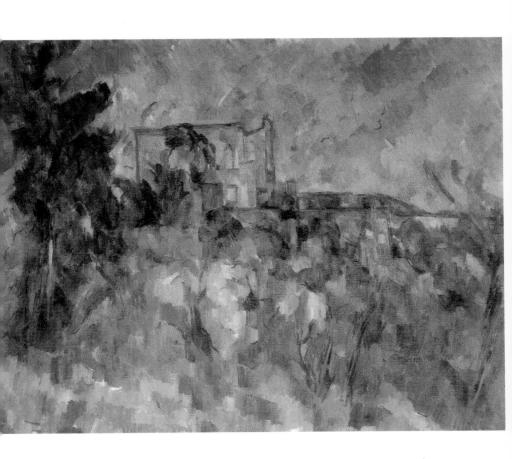

One of the supreme achievements of Cézanne's later period is undoubtedly *Mont Sainte-Victoire*. The dynamic motion permeating this landscape can be sensed both in the movement of the brushstrokes and in the energetic curving of the lines and vibrations of the light-and-air medium.

The Château Noir

1900 Oil on canvas, 73.6 x 93.2 cm Museum of Modern Art, New York

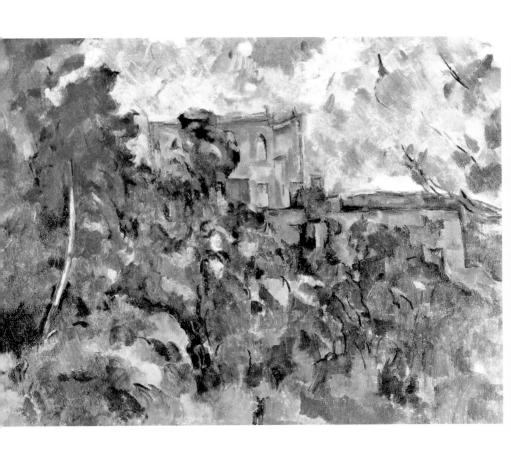

If one looks at Mont Sainte-Victoire from the side Cézanne painted it, one gets quite a different view from that shown in his painting. Cézanne placed houses which in reality are hidden by trees at the very foot of the mountain; he considerably increased the size of the mountain in comparison with the adjacent hollows and tracts of forest.

Flowers (Study)

1900 Oil on canvas, 77 x 64 cm Pushkin Museum of Fine Arts, Moscow

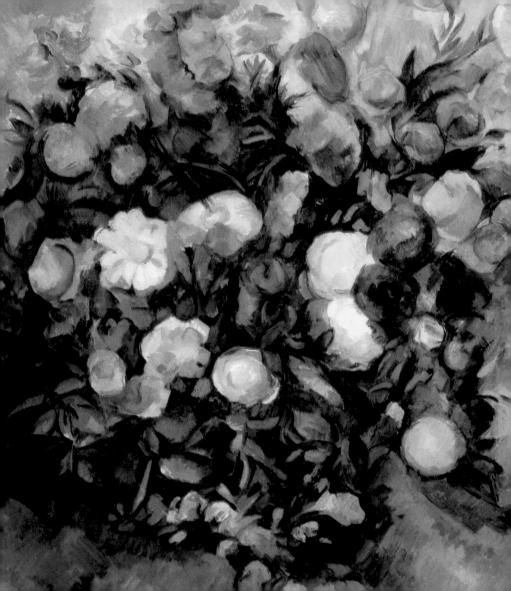

As a result, though the mountain comes closer to the viewer, there is no loss whatever of the impression of inaccessible distance, like the sensation experienced on looking from a valley at a mountain ridge which seems near and far at the same time.

Mont Sainte-Victoire

c. 1900 Pencil, gouache, watercolor on white paper 31.1 x 47.9 cm Musée d'Orsay, Paris

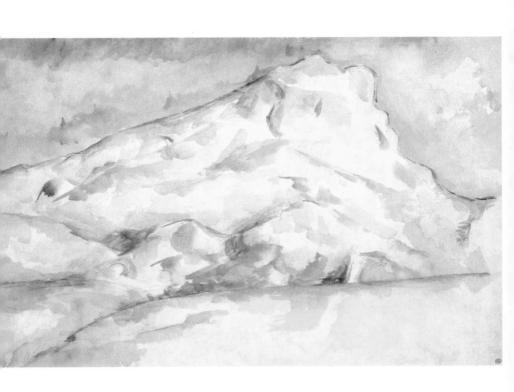

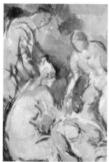

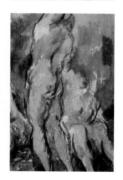

In his *Great Pine Near Aix*, Cézanne was also concerned with developing spherical space. The tree trunk is framed on all four sides by an uneven ring of color in which the green tones of the pine and the carpet of grass are mixed with bluish-violet reflections of air and distance.

Bathers

1900-1905 Oil on canvas, 50 x 61 cm The Art Institute of Chicago, Chicago

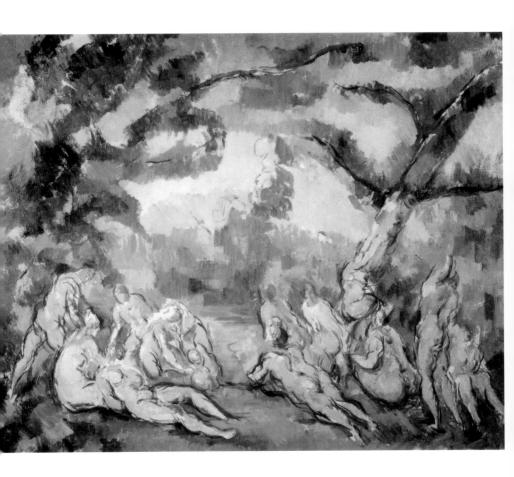

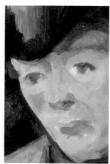

Scholars have noted the presence of this "spherical space" in Cézanne's work more than once. However, claims that Cézanne was the first in this field require a little correction. In his mature years, Cézanne's vision not only became free of symbolic conceptions, but of a host of artistic canons as well.

Woman in Blue

1902-1906 Oil on canvas, 88.5 x 72 cm Pushkin Museum of Fine Arts, Moscow

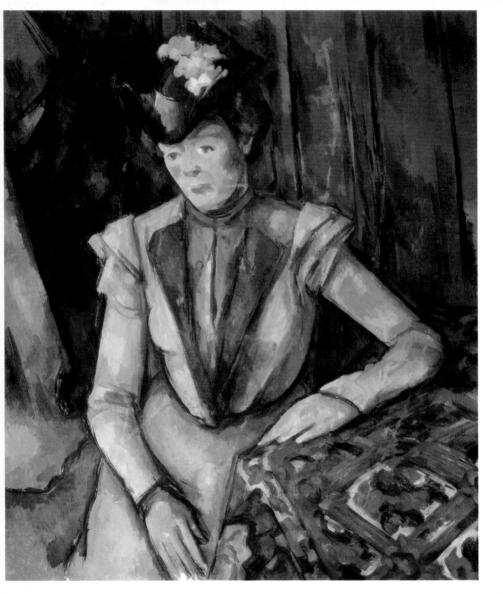

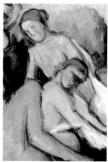

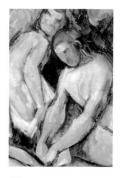

He eventually noticed that in nature all lines bend, curve or incline, and to portray parallels converging in space was to him tantamount to "copying truth from a preconceived type," whereas he wanted "to imitate nature in accordance with truth."

The Great Bathers

1900-1906 Oil on canvas, 127.2 x 196.1 cm National Gallery, London

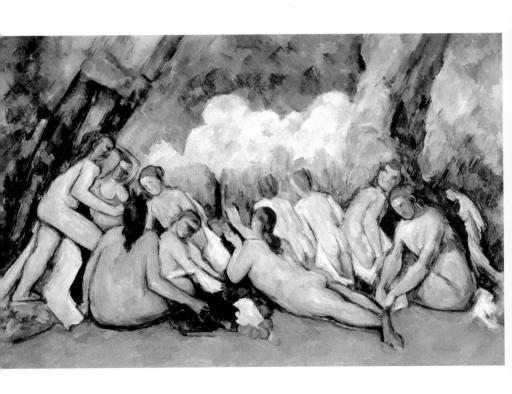

To some extent this led to the stories that Cézanne had defective eyesight. Cézanne himself was very near to believing that his sight was defective and ascribed to it the fact that "the planes overlap each other," while "absolutely vertical lines seemed to me to be falling."

Mont Sainte-Victoire, View from Lauves

1902-1904 Oil on canvas, 69.8 x 89.5 cm Philadelphia Museum of Art, Philadelphia

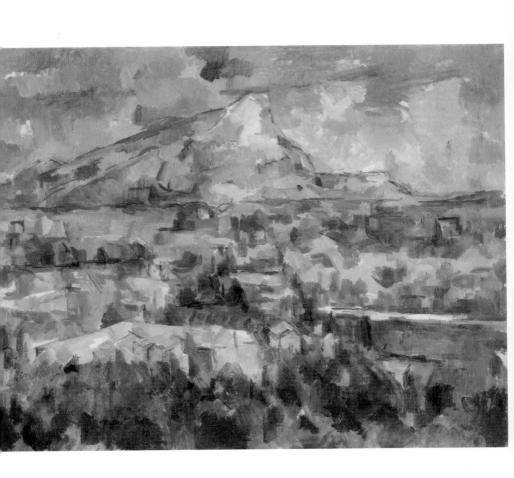

But Cézanne did not want to change his vision of nature and he could not do so. The spherical character of space helped him to convey in the best possible way his pantheistic perception of the dynamic life of nature as a single process uniting and forming in its course all the elements of nature's visual aspect.

Mont Sainte-Victoire

1902-1906 Watercolor and lead pencil, 42.5 x 54.2 cm Museum of Modern Art, New York

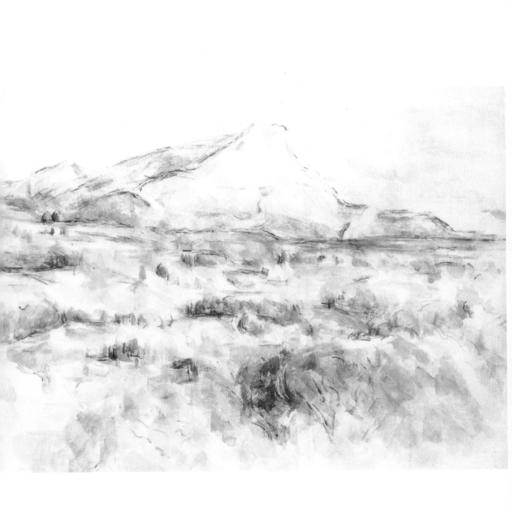

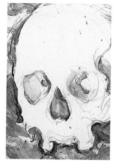

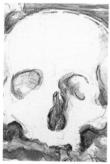

One might say that Cézanne's pantheistic world perception was seen earlier in his *Bathers* series in which he tackled the task of uniting human figures with landscapes. He had turned to this theme back in the 1870s, and had continued with it all through his artistic career. His small study *Bathers* is part of this series.

Three Skulls

1904 Watercolor and lead pencil, 47.6 x 62.9 cm The Art Institute of Chicago, Chicago

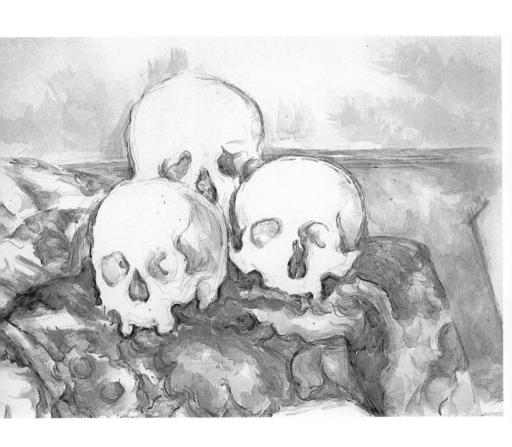

A group of bathers is depicted on a narrow strip in the foreground, and behind them the color patches of the foliage are interrupted by the light blue patches of sky. But is it the sky? Or is it the wide blue surface of the river, reflecting sky and bank?

The Blue Landscape

1904-1906 Oil on canvas, 102 x 83 cm Hermitage, St. Petersburg

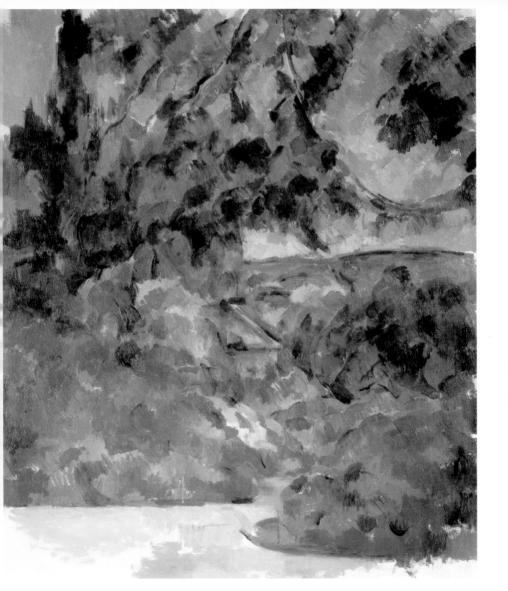

In his later landscapes, Flowers (c. 1900, Pushkin Museum of Fine Arts) or Landscape at Aix (Mont Sainte-Victoire) Cézanne synthesized the principles of organization of pictorial space worked out by him earlier. He was motivated by the same striving to embrace reality as a whole, which now, as ever before, meant for him the fullest possible expression of his sensation of nature.

Mont Sainte-Victoire, View from Lauves

1904-1906 Oil on canvas, 60 x 72 cm Kunstmuseum, Basel

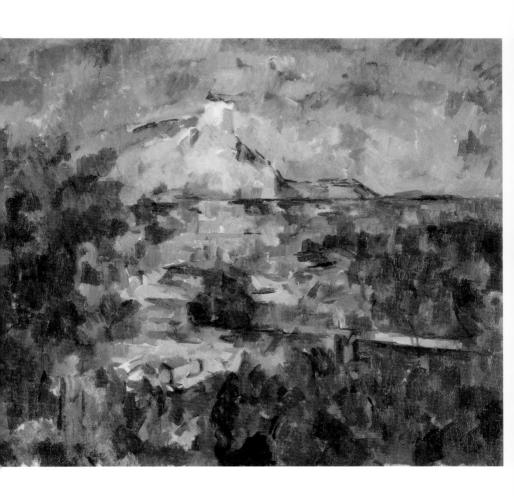

And to achieve this he perfected to the utmost his method of discarding secondary details in order to penetrate the essence of what was portrayed. In these landscapes, nature in many respects loses the concreteness of its forms but acquires instead the dynamic intensity of its existence.

Landscape at Aix (Mont Sainte-Victoire)

1905 Oil on canvas Pushkin Museum of Fine Arts, Moscow

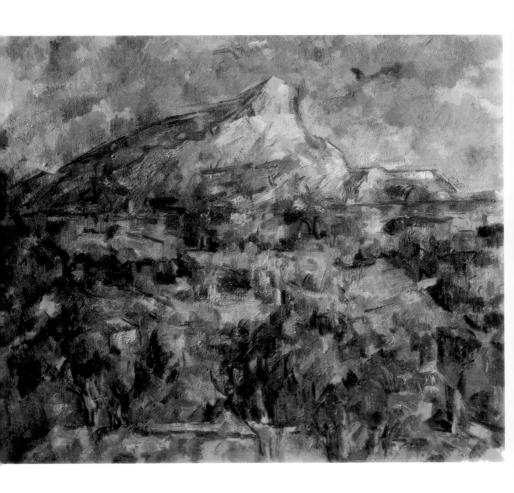

Unlike the Impressionists, Cézanne did not dissolve natural forms in the light and air medium; rather he fused them together, and from this alloy, which has absorbed all the colors and shades of reality, he built the world anew

Landscape at Aix (Mont Sainte-Victoire)

1905 Oil on canvas, 60 x 73 cm Pushkin Museum of Fine Arts, Moscow

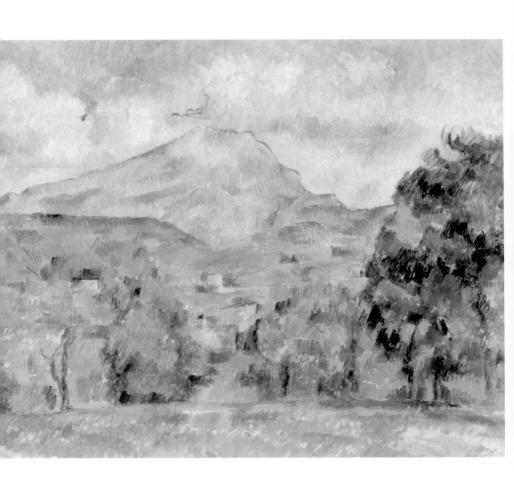

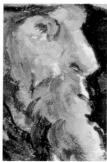

And this process of creation broke off only with his last heartbeat, the last stroke of his brush. Cézanne died on October 22, 1906, from pneumonia, after catching cold while working on his last "motif".

Portrait of Vallier

1906 Oil on canvas, 66 x 54 cm Private Collection, Switzerland

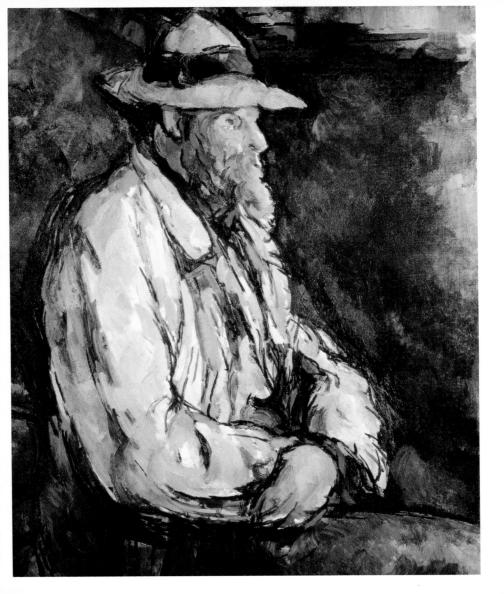

Index

123

Bathers in Front of a Tent

Bay of Marseille from l'Estaque	89
Bibémus Quarry	217
he Black Scipion	25
The Blue Lanscape	239
Blue Vase	151
Bottle of Peppermint	195
Bread and Eggs,	17
Bridge and Pool	163
Bridge in Maincy near Melun	93
The Buffet	61
C	
The Château Noir	221
Court of a Farm in Auvers	99
D	
Dish of Apples	105
Dish with Fruits and Drapery	171

F

Five Bathers

The Great Bather

The Great Bathers

Great Pine near Aix

Green Pot and Tin Kettle

The Great Pine (Mont Sainte-Victoire)

The Eternal Female

Flowers (Study)	223
Flowers in a Blue Vase	57
Flowers in a little Delft Vase	55
The Four Seasons	9
Fruit	91
Fruits	95
G	
Gardanne	139
Girl at the Piano (Ouverture to "Tannhäuser")	31

83

75

133

231

149

207

35

н	
Harlequin	169
House and Farm in Jas de Bouffan	145
House in Bellevue	181
The House of Dr. Gachet in Auvers	49
The House of the Hanged Man at Auvers	51
4	
In the Park of the Château Noir	215
In the Park of the Château Noir	219
J	
The Jas de Bouffan (detail)	143
L	
The Lake at Annecy	209
Landscape at Aix (Mont Sainte-Victoire)	243
Landscape at Aix (Mont Sainte-Victoire)	245
Landscape in Provence	109
Luncheon on the Grass	37
	1971

Madame Cezanne in a Red Armchair (Madame Cézanne in a Striped Skirt)	81
The Madeleine or Sorrow	33
Man in a Cotton Hat	15
Man Smoking a Pipe	1 <i>77</i>
Man Smoking a Pipe	201
Melting Snow at l'Estaque	43
Millstone	189
Modern Olympia	53
Mont Sainte-Victoire	211
Mont Sainte-Victoire	225
Mont Sainte-Victoire	235
Mont Sainte-Victoire, View from Bellevue	117
Mont Sainte-Victoire, View from Bibémus	213
Mont Sainte-Victoire, View from Lauves	233
Mont Sainte-Victoire, View from Lauves	241
Murder	29

0

The Old Woman with a Rosary 205

Pastoral	41
Path in Jas de Bouffan	67
Path of Chestnut Trees in	
Jas de Bouffan in the Winter	137
Peaches and Pears	161
Pierrot and Harlequin (Mardi Gras)	157
Pitcher and Fruits	193
Pitcher, Fruits and Tablecloth	103
Plain by Mont Sainte-Victoire	115
Portrait of Anthony Valabrègue	39
Portrait of Madame Cézanne	121
Portrait of Paul Cézanne, Artist's Son with Hat	167
Portrait of the Artist	59
Portrait of the Artist's Father	21
Portrait of Vallier	247
R	
Road at Pontoise (Clos des Mathurins)	79
Rocks in the Woods	191

S

Seif-Portrait	8/
Self-Portrait	107
Self-Portrait in a White Hat	113
Self-Portrait with a Pink Background	71
Self-Portrait with Cap	47
Self-Portrait with Palette	127
The Smoker	179
Still Life with a Chest of Drawers	125
Still life with a Soup Tureen	85
Still Life with Basket	165
Still Life with Bottles and Apples	185
Still Life with Curtain	199
Still Life with Dish, Glass and Apples	97
The Strove in the Studio	19
Study for the Painting Mardi Gras	159

T
Tall Trees in Jas de Bouffan 135
The Temptation of Saint Anthony 27

hree Bathers	77
hree Skulls	237
rees and House	129
irees in a Park	63
rees in a Park (The Jas de Bouffan)	141
rench at the Foot of Mont Sainte-Victoire	45
wo women and child in an Interior	11
J_{\perp}	
Incle Dominic as a Monk	13
v	
Vase of Flowers on a Table	119
View of the Château Noir	197
Village in Provence	131
W	
Woman in Blue	229
Woman with a Coffee Pot	183